A VISUAL
LANGUAGE

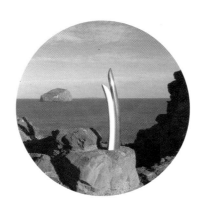

A VISUAL LANGUAGE

ELEMENTS OF DESIGN

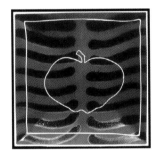

David Cohen & Scott Anderson

Herbert Press
an imprint of A&C Black

First published in Great Britain 2006 by
The Herbert Press
an imprint of A&C Black Publishers
38 Soho Square
London W1D 3HB
www.acblack.com

ISBN-10: 0 7136 6773 7
ISBN-13: 978 0 7136 6773 8

A CIP catalogue record for this title is available from the British Library.

Jacket design by David Cohen

Book design by Susan McIntyre

Printed and bound in China by WKT

This book is produced using paper that is made from wood grown in
managed sustainable forests. It is natural, renewable and recyclable.
The logging and manufacturing processes conform to the environmental
regulations of the country of origin.

Contents

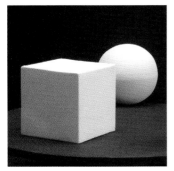

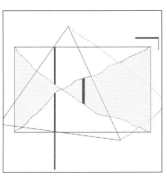

David Cohen, 'Garden Sculpture', 2001

Foreword

'We need to give everyone the outlook of the artist, who begins with the art of seeing – and then in time we shall follow him into the seeing of art, even the creating of it.'
SIR PATRICK GEDDES (1854–1932)

During the writing of this book we had many lively chats on what the point of it should be, who it was for or how it could be used and was it really any different to other books out there.

There were very brief moments of epiphany but the withdrawal mostly resulted in more questions. Questions regarding: What is important in teaching? What is being learned and how should these be applied? There was one consistent theme however, education: art education that embraces teachers, learners and makers and the desire of an individual to learn regardless of previous experience.

We wondered if there was a way to address these concerns in book form.

In our collective experiences as both artists and teachers we found gaps, inconsistencies and failings with much that was written and taught and so it was in the realm of life-long learning that we felt this book had greatest value. The notion that we all have the potential to be learners, open to the possibility of discovering something new and seeing the world differently through being introduced to something familiar, presented in a unique way; this book attempts to fill some gaps, present greater coherence and consistency providing teachers, learners and makers a better chance of understanding and success in their relationship with self, others and work.

Visual language underpins our philosophy. The elements of this language (line, shape, tone, texture, colour) are not new; they exist everywhere in the physical world, in everything that can be seen. The elements are well-documented, conventionally defined as 'the design elements'. But here is where we must take issue, this book strikes out in a new direction and presents a broader perspective.

Definitions can result in a narrow, blinkered mind-set with less than positive consequences for learning. Conventional wisdom in this case diminishes perspective and pigeon holes vocabulary often resulting in confusing and limited critique, a detrimental outcome for both teacher and learner.

Limiting the visual elements to the category of design alone restricts the potential scope of their application for the purpose of critical self-reflection and teacher/learner discourse across all visual art and design forms. This discourse has nothing to do with issues of technical competence or use of materials, things that are often given critical priority where the focus remains centred on 'how to'.

If you are someone who has tried the 'How to ...' books or has never even thought of himself as capable of being able to create something or regards himself as somewhat technically competent or has experienced boredom or frustration or is curious and willing to practice and learn and broaden your perspective, then we think this book will introduce you to the practice of seeing in unique and achievable ways that should provide enough pleasure to last a lifetime.

The introduction gives a broad overview of visual language and the range of applications and uses in everyday life not restricted to the world of art and design.

Chapter One introduces you to a series of carefully designed, two-dimensional exercises, clearly explained for you to try yourself. By doing the exercises you can experience first hand what it feels like to make visual decisions and experience how your decisions contribute towards achieving balance and unity in your work.

In Chapter Two drawing and composition are defined. The compositions described demonstrate increasing visual complexity regarding visual intention and selection.

Chapter Three demonstrates the visual transition from two-dimensional works to three-dimensional forms.

Chapter Four uses figure drawing to describe a visual approach to drawing from observation. The life model can be a particularly challenging subject to represent but here we make connections to everything that we have described in previous chapters and apply the same language, keeping the focus the same for you to realise your intention even when the complexity of the subject is increased.

Chapter Five takes you still further towards realising your expressive voice, describing the importance of developing your individuality and identity through your own work. Dave Cohen describes his thirty year visual investigation using ceramic plate compositions and his personal interpretation of 'nature' and 'geometry'.

The final section introduces eight artist/craftspeople with international reputations living and working in Scotland. Each artist has written a personal statement about the relationships between ideas, visual language and material that provide a unique insight into how master works are made.

Many people may never attain their level of 'visual poetry' but perhaps, after reading this book, you may feel a little more enriched and confident in the knowledge that you now possess a critical foundation to recognise and appreciate those things of visual beauty, value or quality and take pleasure in knowing some of the reasons why.

Scott Anderson
May 1st 2006

Introduction:
Our Visual World

HENRI MATISSE STATED, in reference to his paper cut-outs of pure colour, 'It is a conclusion not a starting point.' This statement by Matisse was the inspiration to reflect very seriously on my own practice and the whole creative process. After 35 years of continuous teaching and making art, I had a strong sense of affinity with and understanding of his beliefs. They encouraged me to bring into focus my methodology and to clarify an investigative framework for the development of my work. The work and ideas presented in this text are the culmination of this effort; my hope is that those who care enough about their own practice may find something of practical use to initiate a starting point for them.

It was important to establish a method of visual investigation not based on conceptual rhetoric or influenced wholly by historical reference. I do not know or trust rhetoric to be of any practical use and I remain acutely aware of specificity in time and place. Historical investigation can be extremely useful in evaluating developments in any visual discipline but it is also vital to appreciate that any point in history is also specific to complex religious, political, social and cultural structures. If the historical reference is to be of any use in your own work, it must be understood with great sensitivity, empathy and acute selectivity. Only then can educated decisions and choices regarding contemporary relevance to your work be made. Misunderstandings and misinterpretations result in superficiality and mimicry.

I recognise myself to be a maker. The drive to fabricate and realise ideas in either two- or three-dimensional forms has always been necessary and of the utmost importance to me in order to reach conclusions about how to communicate my intentions visually. There was a need for something tangible and practical, a platform for critical dialogue where ideas and their manifestations in visual terms were made possible. Defining a structure for visual investigation and coherent, critical dialogue was an important part of this synthesis. The principal visual elements of **line**, **shape**, **tone**, **colour**, **texture**, **form**, **scale**, **space** and **light** are all clearly visible to the naked eye. It was a logical step to focus my methodology through the fundamental action of seeing. This practice was primarily rooted in observation and the discovery through this of relationships that could be fabricated, touched and seen.

The challenge in writing this book lies in the attempt to explain my visual methodology and in doing this make the case from the outset that the visual language is in essence no different to other vocabularies that remain fundamental to learning any discipline, e.g. composing and playing music, the art of literature or working in the laws of science. These comparisons have led me to consider very carefully the possible construction, use and application of a language governing the visual.

In using any language it is necessary to know the basic structure before any proficiency in selection and application. A visual language with a fundamental structure can be clearly identified, selected and applied in any visual situation. Defining and understanding the basic elements of this language and how to apply them is at the very centre of all visual disciplines. The rigorous identification of the visual elements through practice and application over time can critically engage the mind in a visual adventure of infinite possibilities.

This text establishes a coherent visual discourse. It introduces the visual elements in a unique way, not confining the discussion to design principles but instead inviting you to apply the language to your every day experience as maker, teacher, student, and consumer within the environment around you. The elements exist all around us, in all things visual. The elements are presented here like a series of building blocks to form a structure that can be infinitely re-assembled depending on your intention, providing a useful platform for critical reflection, discourse and action.

My purpose is to invite you to reflect and contemplate the purpose of visual language and the necessary foundations that need to be understood, practised and applied. Through this your journey to greater visual discoveries and understanding can be enhanced.

Figure 1 (*opposite*) introduces the broader notion that visual elements can be applicable in all visual scenarios depending on your intention. It is useful to introduce this perspective from the outset in order to establish a greater awareness of the potential of applying visual language in our everyday lives.

At the core lie the nine visual elements. They assume no particular order in this broad context. The four 'spheres' (maker, education, social appreciation/consumption and environment) combine to define the visual world, inter-playing dependent on an individual's choices and experiences. A brief explanation of each sphere will clarify the relevance and application of visual language in the visual world.

Environment

When we consciously apply visual language to our immediate environment a greater visual appreciation becomes possible. We can approach nature and built structures with a keener visual sensibility and recognise the elements present, engaging in a deeper way with our everyday surroundings. Nature and architecture surround us. Applying visual language enables a richer relationship with these phenomena.

The Maker

Whether amateur or professional the maker is involved in a creative act, a practice where the visual elements are integral and continuously considered. The core elements are the practitioner's language for visual communication.

Education

Visual language is the common denominator regardless of medium whether clay, paint, metal, wood, glass, video etc. Teacher and student are in a unique relationship that necessitates discourse, reflection and action. How this is achieved will vary greatly, the core visual elements remain constant (as long as the student produces something!). From this point of action there exists a platform for critique that focuses on the student's approach to their intention, selection and critical assessment. Visual language requires a practical approach and result. Through structured discourse and reflection real change and development can be understood.

Social Appreciation/Consumption

This sphere revolves around the concept of the provision of goods, services, products and the home. Every day people visit museums and galleries, shop for clothes, decorate their home or landscape their

Figure 1

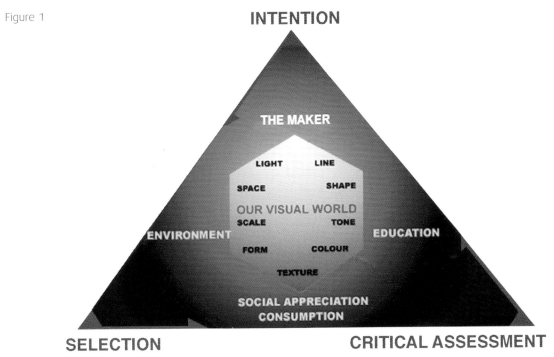

garden. These are activities that primarily engage the visual. A greater informed application of visual language can enhance our decisions, contribute to greater confidence and informed choices. Individuality can be expressed without the mind set of 'being an artist'. Everyone can enjoy the experience of making informed visual decisions that contribute greatly to the quality of life.

Intention, Selection and Critical Assessment

The triangle in Figure 1 refers to these actions as cornerstones to intelligible visual communication in its broadest sense, touching all spheres as passive observer, consumer, active maker, student or teacher. These actions provide clarity of purpose and reveal strategies for future investigation, prompting questions and an enthusiasm for inquiry.

This book focuses on the 'Maker' of art and the core elements that contribute to its creation; there is no limit to this perspective, clearly not marginalised to the area of design alone. Figure 1 helps to illustrate the bigger picture and the contribution visual language can make to anyone with an interest in applying it to their everyday experiences.

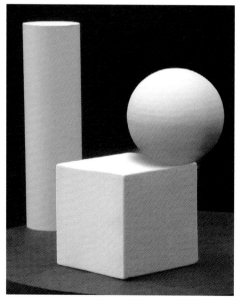

FORM

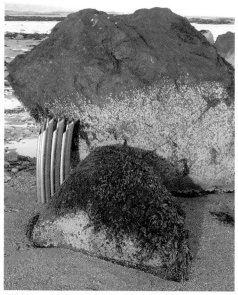

SCALE

SPACE

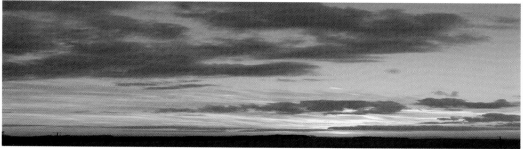

LIGHT

PART ONE
The Visual Element

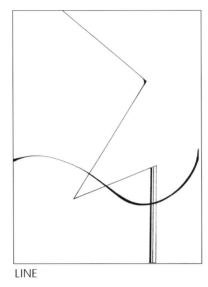

LINE

SHAPE

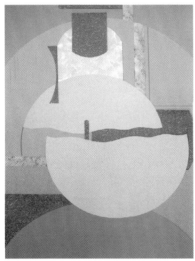

TONE

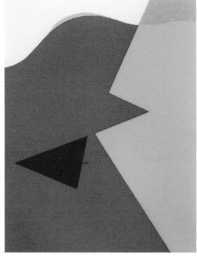

COLOUR

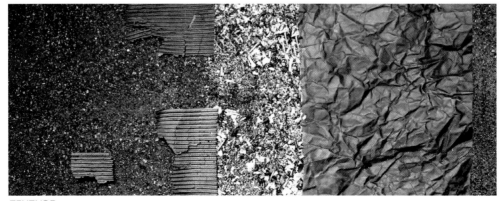

TEXTURE

CHAPTER 1

The Visual Element: Two-dimensional

THIS CHAPTER EXPLAINS EACH VISUAL ELEMENT in a detailed series of visual exercises, exploring relationships as the visual complexity of the series increases. No command in technique is required to identify the elements. Competence in drawing or making is of little consequence. The following exercises focus on what actually happens visually through intention, selection and critical assessment. This will clarify an approach to visual strategies that will assist in visual decision-making. This thought process will be our principal area for reflection in the beginning of our look at developing visual languages.

It is essential to realise that the maker, through the organisation of visual elements, composes the work in ways that can be 'read' in visual terms. This stands apart from any recognition regarding what the work represents, i.e. landscape, still life or figuration. The exercises will clarify this by demonstrating what it means to 'guide' or 'direct' the viewer's vision.

The introduction of each element will begin with a brief description of its implication, from initial concept to conclusion of visual decisions and composition. The elements are explored through practical application while remaining clear and consistent.

With reference to the following drawings it is important to read the descriptions and briefs without forming assumptions. Think about all possible solutions in your own approach to each exercise or question. Your solution is unique and expresses your individuality. Patience is indeed a virtue in this respect.

There is a tremendous difference between intellectually understanding how something is done and the physical process of doing it yourself. For example, if I were to demonstrate how to throw a simple form on the potter's wheel and verbally explain step by step how to achieve this, intellectually the novice could understand the procedure immediately. If the same person wanted to achieve a similar result by doing it himself, then it could take weeks or months of continual practice on the wheel to achieve a competently thrown form. There would need to be total focus on technique in the first instance. Having achieved competence in throwing, an application of the visual elements is what will be needed for the sustained growth of ideas within the craft of clay.

Technical competence and knowledge in any medium is never enough to realise visual intention. Technical knowledge responds only to the mechanics of how material and physical relationships function. Although important, this competence will only serve to answer technical questions.

The questions that sustain enthusiasm and prevent boredom over time are:

What am I to do?	– Intention
How am I to do it?	– Selection
Why this way ... what if I?	– Critical Assessment

These critical questions lead to the deeper investigation of self in relationship to visual language.

Conventional Thinking

Task: Divide a piece of paper into two equal parts using **Line**.
The conventional approach to this visual problem most commonly results in one of three solutions: the horizontal, diagonal or vertical line.

These responses have creative limitations, lacking any individuality. The next three approaches to the task are more inventive and express the individuality of the maker, demonstrating the importance of adopting a mind-set that thinks outside convention and considers other possibilities. The range of possibilities is, in fact, infinite and depends, to a degree, on accumulated knowledge, experience and working methodology.

Introducing Line

Q. What does a line do in a strictly visual sense?
A. In the examples below the dot implies the beginning of a visual statement.
and
Q. What is the response of the viewer in relation to the intention of the maker?
A. The viewer follows the maker's intention; creating a line by visually linking dots regardless of the varying spaces in between.

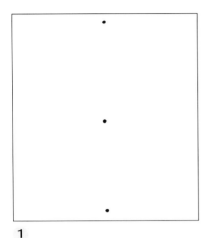

1

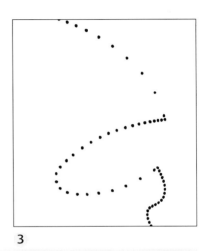

2

3

In No.1, the dots could be viewed as being in line without necessarily creating a visual line as in No. 2. In No.3 the maker has used dots in an individual way to express visual

direction, adding interest through the variation of spaces between the dots. Confidence will come with practice, resulting in lines that are consistent with intention.

The line can only be evaluated in relation to its physical boundaries and in the examples that follow these constitute a two-dimensional piece of paper.

Two Contrasting Lines

The following series of drawings demonstrate the visual placement of two lines of equal thickness and the increasing visual complexity achieved through decision making and variety.

Here are two contrasting lines. The horizontal line gives the impression of a flowing movement without interruption, while the vertical line is ridged and angular. The relationship between these contrasting lines becomes an exercise in visual placement.

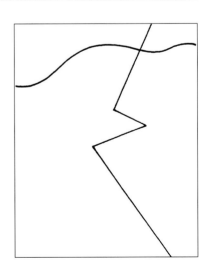

The series overleaf demonstrates three more examples of visual placement with two contrasting lines. The permutations are infinite. Try this yourself. Your results will be your unique approach and provide you with a starting point to explore the visual relationships described below.

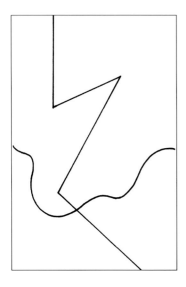

Through this series of drawings an awareness of the spaces (shapes) on either side of the lines become an important consideration and of equal visual importance to the line relationship. Similarly, abstract shapes are created here by the placement of the lines.

Working in series is extremely useful for the purpose of critical assessment. Without visual evidence for comparison, a coherent critical evaluation does not exist. The larger the number in the series, the more acutely aware one becomes of the subtlety that is possible in discovering new variations and refinement within the theme.

Visual Direction

In illustration 1 both lines are of equal thickness and density, resulting in each line having equal visual importance without directing the viewer to any specific focal point. Visually there is an interaction between both lines without one line dominating the other, thus resulting in an 'ambiguous' visual relationship. In illustration 2 the **intention** (decision) is to thicken a portion of the horizontal line creating an **accent**. This clearly elevates the attention of the viewer to the upper part of the drawing, creating focus. Through visual **selection**, another dimension has been added. The maker has the capacity to direct the viewer in any chosen visual direction.

1

2

All visual decisions can be defined as **drawing**. The act of drawing is conventionally understood to be a two-dimensional representation of reality (figure drawing, still life, landscape). For all practitioners who create either two- or three-dimensional work the term drawing can be applied. The complexity of the image grows through the application of one element or a combination of elements within a single visual statement. Intention and the act of drawing refer to the physical placement of the elements.

Increasing Emphasis

The maker uses line and accent selectively in order to direct the viewer's vision and communicate increasing emphasis.

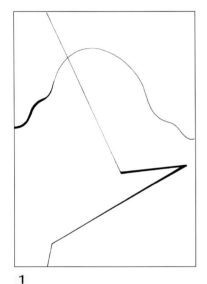

1

2

1 The intention is to direct the viewer in opposite directions by accentuating the arrow-like shape on the right, opposed to thickening the horizontal line on the left. This has been accomplished simply by using the same weight of accent on both lines. The accents compound the intention and visually create further interest.

2 This Illustration establishes strong visual support. Starting at the base of the vertical line through the horizontal line, with added emphasis by way of two extra lines in close proximity. The uncomplicated curve of the horizontal line emphasises a flowing feeling because of the variation in thickness imposed on it. The primary focus (or 'weight') is concentrated in the lower half of the drawing. Travelling up the vertical line there is an additional accent where the line changes direction. This is minute but important in relation to balance, allowing the viewer to contemplate the top half of the drawing, enough for the eye to pause for a brief moment.

This series is valid when both the positive and negative spaces are observed as an organisational whole. The positive elements are the lines and, surrounding the lines, are the negative spaces (shapes). There cannot be a positive without a subsequent negative ground being created, an awareness of both are essential to overall compositional unity and organisation.

Simple Line and Shape Relationships

When a triangular shape is introduced to the line drawings below, it clearly becomes the dominant focal point. Changing the scale of the shape and/or the introduction of tone or colour would also minimise or maximise the visual effect the viewer would experience. The following six drawings describe shape placement in relation to their directional impact in proximity to the lines or as an independent entity in the surrounding space.

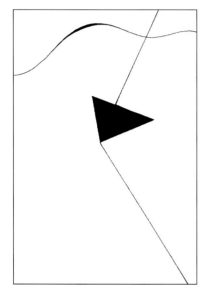 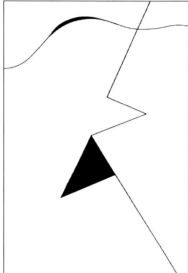 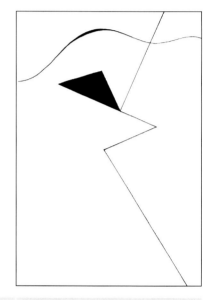

1 The focus is much stronger in the centre of the paper, the overall structure has not changed dramatically from the original drawing (page 17).

2 The shape is now pointing to the lower left hand side of the paper and is firmly attached to the vertical line. The position of this shape attachment creates a relationship between the black 'positive' triangle and the 'negative' triangular shape created by the vertical line.

3 The black shape no longer has the visual security of being attached. The visual stability of the black shape is achieved by positioning it along an existing straight edge (as in the previous drawing). The black triangle has a strong indication of pointing upwards and creates a visual relationship between shape and accent. It also consolidates visual focus and interest towards the upper part of the page.

4 The shape in this position is slightly ambiguous. The points of the black triangle are placed on the vertical line creating multiple directions up, down or to the left.

5 The shape has been moved directly to the far left side of the paper. Even though it has been moved from its position in No.4, it still has a diagonal link along an imaginary line from where it previously existed. Compare Nos 4 & 5.

6 The absence of visual links or associations within the existing lines, make it more difficult for shape and line to have any relationship to each other. This is why intention is so very important. This floating shape is not in compositional unity with the lines. Only if this were the intention, does it become valid for critical assessment.

Adding Tone and Colour to Line and Shape

1 The triangular shape is minimised in importance by changing its colour from black to a colour value closer to the white paper. The accent colour has also been changed to relate sympathetically to the shape.

2 In this drawing the concentration on line has shifted to what was previously referred to as negative space. With the introduction of a range of grey **tones**, the negative spaces have taken on their own identity as **shapes**.

3 The **tonal value** is exactly the same in all shapes. The only way to identify the shapes is to vary the colour. In keeping the **tone** the same, it does not matter how dense or subtle the colour is, the all over effect will visually communicate a unified composition.

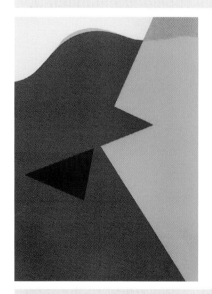

In drawings Nos **4**, **5** and **6** (*left to right*), **colour** is used to create atmosphere (warm and cool),

mood (loud and quiet) and focus on accents and shapes. Each one has a different **intention** evident in

their presentation. Variations on the theme are infinite.

Integrating Geometric Shapes

For the purpose of demonstrating visual integration, basic geometric shapes will be used. The circle, triangle and square lack personality because of the purity of form.

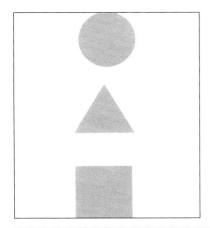

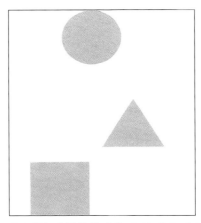

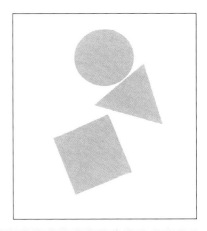

1 When presented in the above manner, the three shapes are very diagrammatic and express little except to define what each shape represents in a two- dimensional format.

2 The square and the triangle relate in placement and in so doing a degree of intention is evident. The awareness of the negative space around these geometric shapes has also altered and relieved the diagrammatic sterility of the previous example.

3 If the **intention** to express a haphazard effect through placement is communicated, then the above example has some validity. It gives the impression of being random.

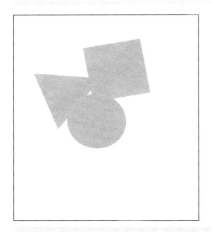

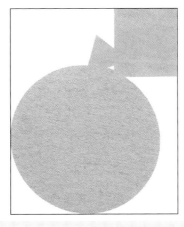

4 By moving the three geometric shapes together, it does not motivate a great deal of interest no matter what their positioning may be due to the similarity in **scale** of each shape.

5 In this example the variation in **scale** offers considerable visual improvement.

6 Total integration through enlargement has left it to the imagination of the viewer to complete the shapes within and beyond the borders of the background. Because of this enlargement, the negative spaces are easily identifiable and take on their own individual importance.

Introducing the Element of Texture

Source material is extremely important when selecting images which will communicate the meaning intended. Extensive investigation can enlarge the choice of textures as a major or minor component. Photography is an excellent medium for recording. I used a digital camera which allowed images to be reproduced through the computer and provided a filing system by transferring the material onto a CD.

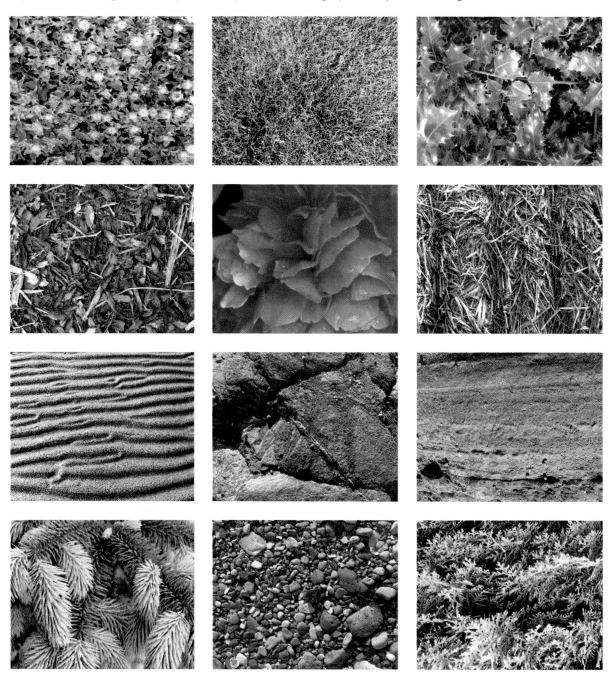

There are primarily two forms of textures: simulated and actual. In a two-dimensional framework simulated textures take the form of mark making and photographic images of textural reality. The technique of collage is used to assemble actual materials of different textures on a two-dimensional surface. The first six illustrations deal with mark making and photography. Illustrations 7 and 8 are actual materials which follow the same format as illustrations 5 and 6 (*overleaf*).

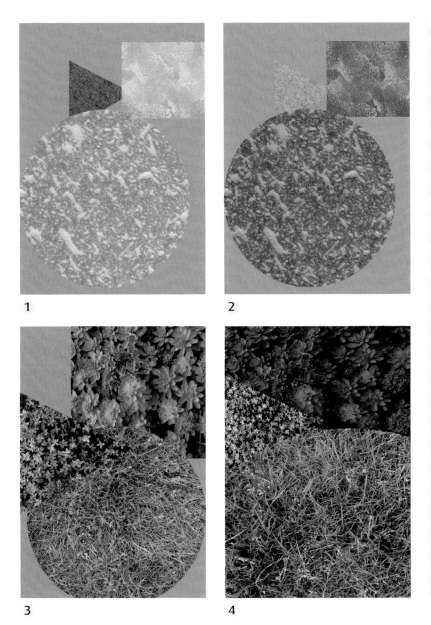

1

2

3

4

The format of illustrations 1 and 2 has been taken directly from illustration 5, page 23. Simulated textures have been applied on various coloured paper with paint, chalk, and ink.

In illustrations 1 and 2 the colour and scale of the geometric forms has stayed the same. The tone of colours has changed. The small triangle in illustration 1 draws attention because of its darker tone in relation to the circle, rectangle and background. The reverse happens in illustration 2.

In illustrations 3 and 4 photographs of textures from the garden were used to illustrate the different scale of vegetation within the format of the three geometric forms. The layout has been taken from illustration 6, page 23. All three forms are similar in tone. The shapes are overlapping one another on a neutral background and read as singular units as in illustrations 1 and 2, but are more integrated.

Scale and placement of shapes without a background has given illustration 4 a pictorial unity. The scale of the foreground in relation to the other two shapes emphasises a feeling of depth. Tone has also played its part in defining the receding layers. This also demonstrates a thought process which involves **intention** and **selection**.

25

All four illustrations on this page are basically the same format. The reason for this is to enable the viewer to focus on the textural differences in each illustration and visually what they imply.

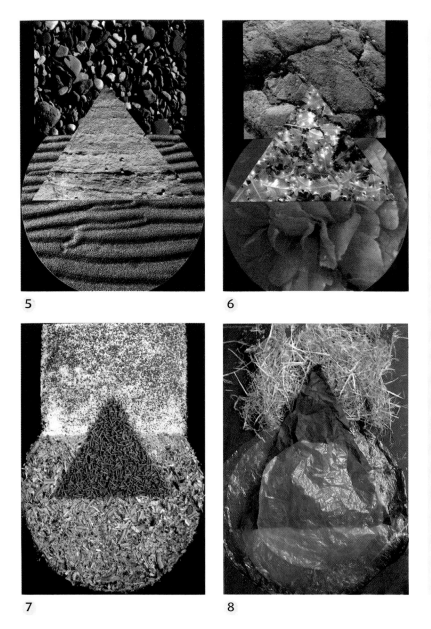

5

6

7

8

In illustration 5 each geometric figuration identifies the subject it represents. Pebbles, rock and sand are brought together through a similarity of tone but remain individually descriptive of their location.

Illustration 6 is designed to help the viewer become aware of the physical feeling of each component. The triangle of holly depicts a prickly form of vegetation in contrast to the circular form of the rose being soft and delicate. The rectangular rock portrays solidity and weight.

Woodchips, white silica sand, and roofing nails make up the components of illustration 7, and are textures organised on a black background. In figures 5 and 6 the photographs represent details which were cut out and fabricated. These are actual materials and relate more to the definition of collage.

The casual approach to the assembly of illustration 8 and the feeling of depth is due to the quality of the materials used. By crumpling the plastic and black paper in relation to the straw, the materials are given a feeling of low relief through the use of a directional light source.

CHAPTER 2

Defining Drawing and Composition

EXAMPLES OF WHAT ARE CONVENTIONALLY RECOGNISED and appreciated as drawings have been well documented throughout the history of art. From the earliest known cave drawings to the present day examples can be understood in relation to social, cultural and personal approaches taken by the society or individuals of any given period.

Drawing is understood, in a conventional sense, to be the placement of marks on paper for the primary purpose of representing reality. For our purpose here however, it is important to broaden the concept and its application. This becomes necessary in relation to the multivarious use of visual imagery in all aspects of our daily lives through mediums such as advertising, cinema, television, personal computers and the internet. Making rapid intellectual sense of this visual bombardment requires individuals to process information relevant to their particular needs, wants and desires, often only requiring a split second look resulting in 'I like it' or 'I don't like it' response. This is a reflex response that does not merit further criticism and is often not based on anything logical.

The case here is to invite you to practise applying visual language. Through this discipline of understanding visual decisions which relate directly to our daily lives, the reflex action of looking becomes a more critical process of seeing. Visual language can inform visual choices through the development of a more critical base.

Drawing is a matter of placement and organisation governed through observation. If taken in its broadest context, this definition can be applied to all visual activities and disciplines including fine art, design, architecture, photography, choreography, landscape architecture, town and country planning, animation, computer graphics and film making to name a few. The meaning of drawing can be re-addressed within this broad landscape of visual perception and presentation.

Composition, in essence, could be described as **the arrangement of visual elements to communicate intention**. The following examples will describe the arrangement of elements and specifically what influenced decisions of placement. It will begin with abstract simplicity, evolving eventually into the introduction of representation. This chapter will be confined to the analysis of two-dimensional arrangements.

The first composition is constructed through the method of collage, leading on from the previous chapter. Simulated textures are cut out along with various shapes and applied to a background sheet. To understand how visual decisions were made in the following illustrations, the process of assembly and integration is explained. The visual elements of line, shape, tone, colour, texture and scale are represented in the final illustration of this composition.

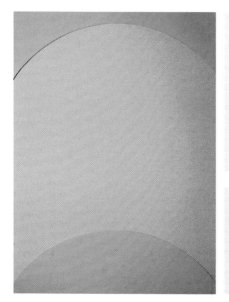

The intention is to use shapes which are derived from a geometric format and visually do not suggest anything beyond the shapes themselves.

The two blue shapes set up a symmetrical foundation on which to apply the simulated textural shapes. Tonally the blue shapes are quite close to the background sheet. This may or may not set up the mood as the composition is assembled stage by stage. Intention is not as rigid as may be implied at this initial stage. An openness to visual suggestions together with intention enable a degree of flexibility in the working process as more textural shapes are applied.

Right Simulated textured strips of paper are placed at right angles to each other forming an asymmetrical counter movement to the symmetry of the blue shapes.

The three simulated green shapes serve directional importance. Two are similar shapes but differ in scale. The smaller shape indicates a downward movement. The middle horizontal shape suggests movement to the right. The green shape at the lower left partially conforms to the blue shape and describes direction to the right.

The layers are governed by visual direction and relationships between shapes. The layers must satisfy one's own compositional criteria at each stage of application. As the vocabulary of the visual language grows through repeated compositional involvement, a greater command in visual decisions will exist and intention can be made clearer.

A circle has been placed partially over the right angle strips of paper and the lower green shapes. In the present position it is dominating the composition by simply being laid on top of the other shapes and being relatively in the centre.

Through **critical assessment** the solution to the compositional problem of dominance may be resolved through an inter-play between the circle and the shapes beneath.

Right Cutting the circle does several important things: It gives a strong horizontal movement against the original vertical compositional format. Cutting and separating the circle also allows the green shape beneath to retain its original scale and directional influence. In addition, shifting the top half of the circle to the left adds an asymmetric element to the composition resulting in the visual effect of holding the focus in the centre through the undulating cut.

To balance this central focus, a play between a strong upper movement created by the white shape and counter movement by the smaller green shape laid on top, brings the vision downwards once again. This also allows the vertical and the horizontal to become more integrated in the composition without either dominating.

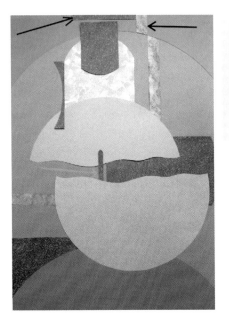

Critical assessment of selection is scrutinised in relation to scale. In the previous example large shapes are predominant. In this example, smaller shapes are added as accents and help to create visual depth (pink arrows). Offsetting the vertical shape at the top of the composition enables the blue paper to continue without interruption on both sides of the green shape (black arrow). Another accent strip is placed horizontally on top of the upper green shape. This helps the containment of the upper shapes within the compositional boundaries (blue arrow).

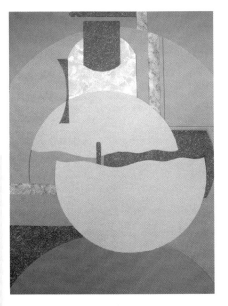

Simulated texture (*Right, top*)

Line is the last element to be added to the composition. The blue line is of the same tonal value as the blue paper. This enables the viewer to associate this line with the colour of a shape that has previously been established. The blue line on the left conforms to the circle and has a downward movement extending the upper half of the circle to the horizontal shape underneath. This also acts as a counter-movement to the small vertical green accent placed in the cut of the circle. Another right angle blue line is drawn on the upper right hand side. This reflects the right angle already positioned in the earlier stages of composition. Both blue lines are vital visual links between the left and right sides of the finished composition. Organisational unity and balance is now finally realised within a relatively complex composition. There is more visual interest for the viewer as compositional (visual) decisions involving the careful arrangement of large and small shapes (scale), tonal variety (light and dark areas), concealing and revealing shapes, subtle use of lines, textures and colour are combined through intention and selection.

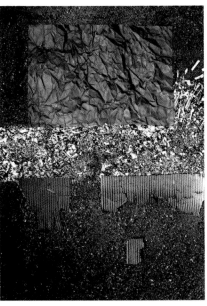

Actual texture (*Right*)

This composition deals with actual texture following selective organisation. These textures were taken from a waste bin – crumpled black paper, burnt sawdust, burnt and partially disintegrated cardboard, and woodchips. They all have a relationship to each other through colour, burning, and the nature of the materials themselves. They were used as found.

The **intention** here is to assemble a composition of actual materials with varying textures and scale. The crumpled black paper and the corrugated cardboard had a particular dimension while the woodchips and sawdust were used to cover areas which were flexible in relation to compositional changes. Direction and the element of light enhance the textural surfaces dramatically.

The elements of line, shape and colour are used to demonstrate how compounding the arrangement of the elements affects the ultimate composition. The application is restricted to straight edge and free hand lines which are permanent marks on a white sheet of paper. This is in contrast to collage where the ability to change arrangements is flexible. Decisions have to be made in relation to the selected lines and shapes already established.

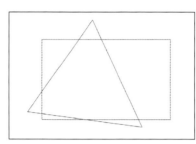

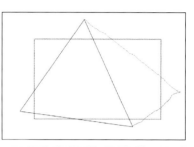

The intention is to work with line and basic geometric shapes. The rectangle is positioned in the centre of the page. The consideration of the next geometric shape will have to deal with additional shapes created by its overlay.

The triangle placement has made additional shapes inside and out of the rectangle. Each addition will have its own influence on the visual outcome of the illustration. The thickness of red line has remained the same in both geometric figurations.

Intention and suggestion, in many cases, work side by side. The triangle has suggested the possibility of a pyramid which gives an additional dimension. The lines are drawn free hand in contrast to the straight ruled lines of the rectangle and the triangle.

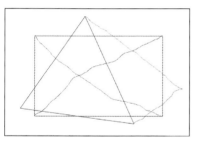

Continuing with free hand drawing, the formation of diagonals within the rectangle reinforces the free hand quality of lines and is also identified by change of colour.

The balance between rectangle and triangle is similar to the previous illustration. The introduction of the blue line becomes visually dominant and divides the rectangle in two.

Separating the blue line allows the blue diagonals to have a degree of visual equality with the stronger blue vertical. The flow from corner to corner of the free hand drawn blue lines was not disturbed.

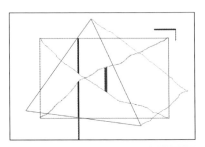

The extension of the blue line has given this illustration a visual support. Changing the colour to red has also enabled the eye to follow around the red line of both the triangle and the rectangle. Having the extension blue would simply carry the eye straight up.

The strong accent of another red line and its location opposite the separation in the blue line has emphasised concentration within the pyramid. The weight of the red line, being heavier than any other line, has a great visual command.

To counter this centralised focus, an additional accent is made outside the rectangle. A link between the vertical blue line within the rectangle and blue right angle accent lying outside the rectangle is established. The central domination now has a visual play between the two blue lines.

The format here remains the same as the images above. Neutral grey is used as a background or infill which changes the visual perception of each illustration. The maker is capable of 'steering the viewer's vision' through conscious arrangement and rearrangement of compositional formats.

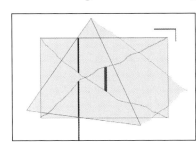
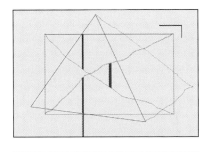
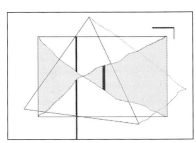

Variation on this theme may be extended through the introduction of colour, texture and tonal differences. Building a visual vocabulary through practice will assist the selective process applied to composition and communication.

Many of the illustrations in Chapters 1 and 2 have been fabricated through a computer program. Today the computer can be considered as a tool in its own right. The construction of composition governed by intention, selection and critical assessment applies to all tools and media dealing with

the placement, organisation and presentation of the visual. Although the computer is capable of many visual applications, an adequate **selective process** needs to be developed in order for the computer to serve the intentions of the user.

The visual elements presented in a two-dimensional format were designed, organised and described in such a way as to let you experience the visual development, decisions and changes that took place as the maker applied each element or made a visual decision adding to the increasing complexity of the compositions. The visual coherence and understanding gained through this approach presents visual language in a clear way that leaves a basis for a critical dialogue that focuses on work produced.

This is not a dialogue that concerns itself with concepts, written statements or subjects that are not materialised. This process necessitates action and visual evidence to engage both maker and viewer. Visual choices, decisions, intentions and selections will always be unique to individual makers through the working methodologies that they are enthusiastic about. At the very core of this is visual language and only through practice and understanding of its role can enthusiasm, progress and development be sustained over time.

The following chapter continues to explore the visual elements in a three-dimensional format to include the additional elements of form, scale, space and light. The act of drawing continues in this exploration as the visual elements are selected and applied with consideration to three-dimensional composition and the visual issues that this presents. The merits of working in series will continue to be realised in the progression and coherence of how the work will be 'read' by the viewer.

CHAPTER 3

Transition from Two-dimensional to Three-dimensional

THE TRANSITION FROM TWO-DIMENSIONAL TO THREE-DIMENSIONAL can be established in a number of stages. This transitional development facilitates an awareness of scale, light and viewing position which affects the ultimate presentation. A series of illustrations demonstrates the evolution from the flat to the round.

In the above construction string and rope were applied to a white board 4 ft x 8ft (122 cm x 244 cm). This method of application allows greater flexibility without, for example, being drawn directly on the background as in the illustration below.

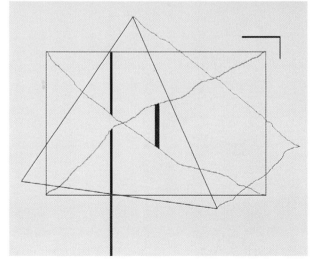

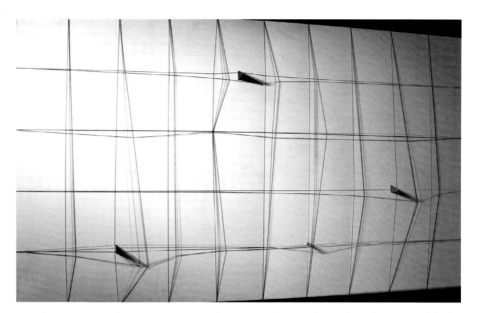

By the process of moving outwards from a flat surface, the element of **light** adds another dimension. Light is capable of drawing lines by creating shadows. The quality of shadow will depend on the positioning of the light source and the distance from the working surface. In the above illustration the light source is being directed from the left hand side. By pulling the red string out from the flat surface with small blue triangular spacers, vertical shadow lines are created by the directional light.

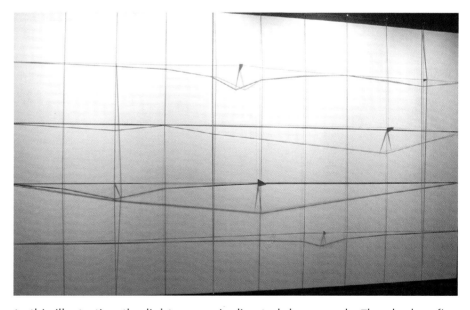

In this illustration the light source is directed downwards. The shadow figuration gives the panel a horizontal feeling even though the red string grid has not been changed dramatically from the illustration above.

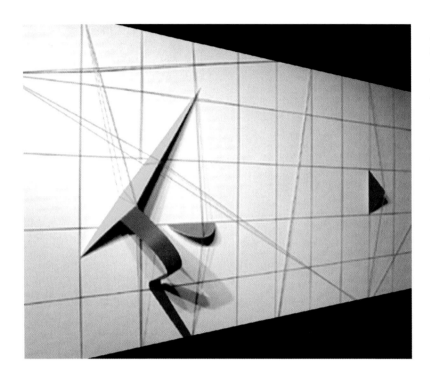

Moving further out from a flat surface the viewing position become critical in experiencing the work. The viewer becomes very aware of the different relationship between all the protruding shapes.

The blue string is a counter movement to the uniform grid of the red string.

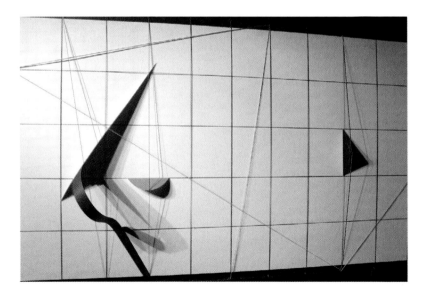

The red triangle points directly outwards at a 90° angle, the blue half circle slightly downwards. The large triangular shape is placed not to conform to the red string grid but to relate more to the blue string in its angular position. A red ribbon form has given the entire composition a non-rigid element, helping create interest and enclosing space. Directional light also plays its part in creating another significant visual dimension to the work.

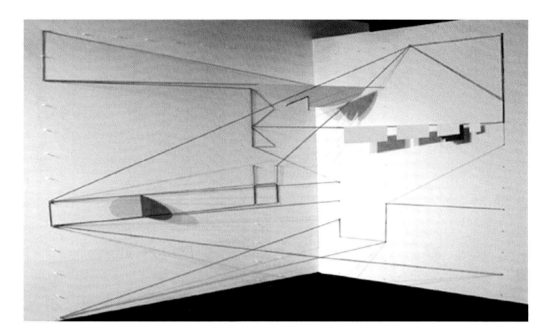

These two compositions have been constructed using the same modular nail arrangement. Working from corner to corner creates a space which takes the transition from two to three dimensions another step forward. The illustration above has a design element which carefully assesses the relationship between line, shape and shadow. In the illustration below there is no interplay between the various elements which are present above. Nevertheless, a strong changing relationship is present as one's viewpoint continuously traverses the 90° angular space.

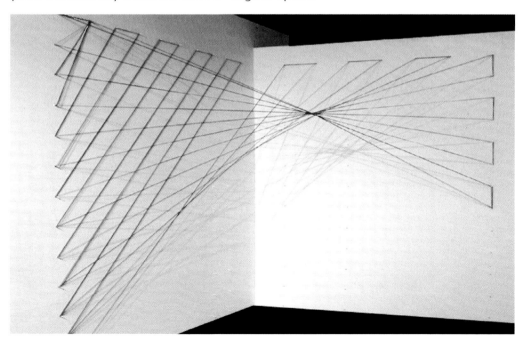

 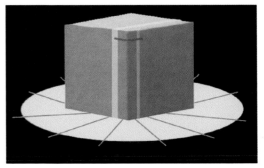

Viewing a two-dimensional work can be experienced within a 90° angle. The entire image is visible with a minimum amount of distortion. Scale and space are frozen within the chosen boundaries. When experiencing three-dimensional objects, scale, space and light dramatically affect the work in relation to the viewing position.

The third dimension depends on movement either by the object rotating or the viewer rotating 360° around the object. Looking at three-dimensional work demands an appreciation of the changing relationships which become evident through rotation.

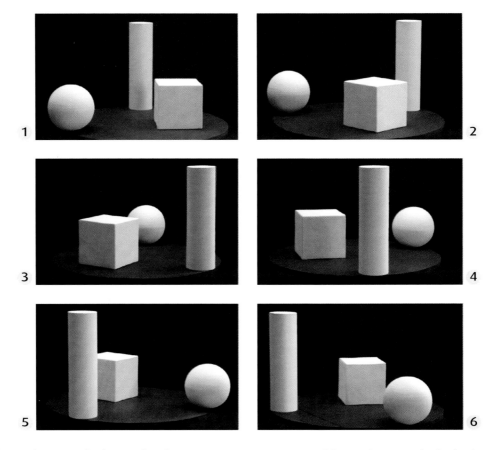

The sphere, cylinder and cube were set on a turntable and rotated clockwise to demonstrate the changing relationships between the three geometric forms.

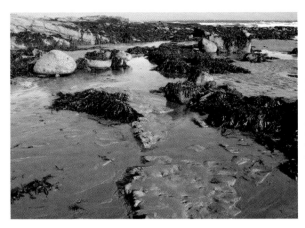

1 Experiencing the third dimension involves the assessment of the environment. All the visual elements of **line**, **shape**, **tone**, **colour**, **texture**, **form**, **scale**, **space** and **light** are evident in the above pictorial beachscape. Recognition of these elements and their relationship to each other is being able to read them. Weather conditions may also have a dramatic visual affect in relation to involvement.

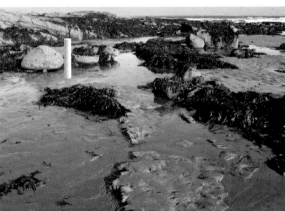

2 The placement of a contrasting geometric form within this natural setting is extremely dominant. Visually it is impossible to avoid within the complexity of the surrounding elements. It has the power to evoke questions of why it is there, and who put it there. It will evolve in its relationship to the other natural forms as the viewing position alters. It has the ability to hold one's concentration through the assessment of relationships to the environment or purely in curiosity terms. There is no doubt that the cylinder was purposely placed in that location.

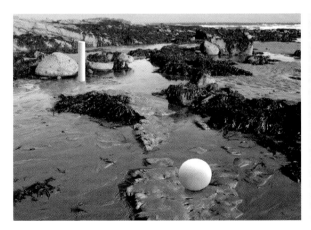

3 The introduction of another geometric shape gives a sense of visual organisation. The alignment and distance between the geometric shapes can be concisely evaluated. The involvement of human placement now has a stronger degree of intention.

4 Adding the cube establishes a triangular structure. The natural surroundings now become a contrasting environment for the placement of a geometric visual triangle. Curiosity as to why they are there may still exist, but a sense of deliberate positioning is communicated to the viewer.

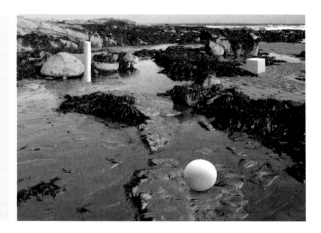

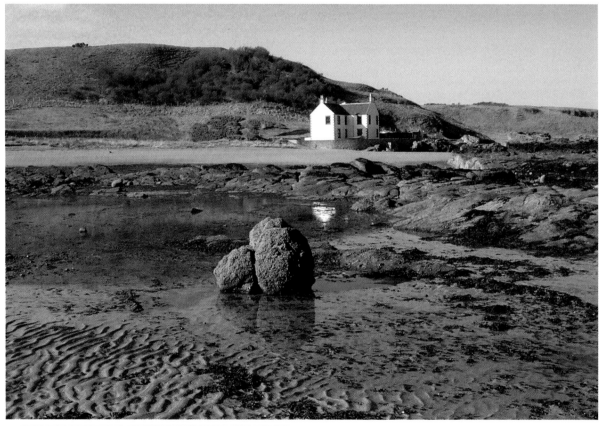

5 In this photograph there is no question of placement. The rocks and building are self evident. On the other hand, this was carefully organised compositionally to communicate my intention of depicting the relationship between the rocks and the building through the manipulation of **scale**, **space** and **light**.

CHAPTER 4

Analytical Observation Using the Life Figure

Significance and value

In the three previous chapters an assembly of images, based mainly on a geometric and collage format, were used to introduce the elements of the visual language and their significance. The recognition and application of these elements present little anxiety in understanding the logic and relevance in the organisation of a visual statement. When the beginner is confronted with the life figure, however, anxiety and insecurity will exist. Within the specific framework of representational realism, one has to follow the structure and physical attributes of the model without taking artistic liberties for their own sake. It is essential to recognise the numerous problems which need to be addressed in order for the drawing to be convincing. In all visual disciplines, including life drawing and modelling, the visual elements are present. The application of analytical observation will identify these elements and create a foundation for practical problem solving.

Life drawing and life modelling for the beginner have always been, and will remain, a daunting experience. The question is; what is the value and relationship of this discipline to the visual language and personal development?

My first introduction to visual language came through studying the human figure as a sculpture student at Edinburgh College of Art in 1958. My teachers at the time all used the figure in their own work. This was common at a time when art education in Scotland still followed a traditional academic framework where the study of the human figure was an integral part of learning.

This traditional approach used the figure as the sole source for establishing a visual foundation upon which the student learned to recognise, select, apply and evaluate the visual elements. This rigorous practice was compulsory and followed a demanding daily schedule, drawing from the figure, life modelling and learning to use the figure in composition. This was done with reference to an understanding of the significance of the figure in art history.

It is not the purpose of this book to argue for a return to this tradition in art education today. Art education has changed, reflecting changes in art practice and the place of art in society. The figure, rightly or wrongly, is given less attention now. What remains true, however, is the existence of the visual language and its relevance to all forms of visual communication.

I still believe the study of the figure as a discipline has contemporary relevance. This chapter will attempt to clarify this rationale and its relevance as a lead to the act of analytical observation.

The Intention, Selection and Critical Assessment 'triangle' in Figure 1 (page 11) can now be elaborated on here as these actions become central to any application of the visual elements.

Intention – What am I to do?
This question is often the first and most difficult question the beginner with a limited visual vocabulary has to confront. The creative experience is, in essence, solitary, self-directed, and therefore necessitates a focus on personal interests, ideas, feelings and passions. Through an acknowledgement of these, it becomes possible to clarify **intention** as a launch for visual investigation. Intention is theoretical and abstract. It evolves into the work as a result of selection and critical assessment.

Selection – How am I to do it?
The process of being visually selective, making choices and decisions regarding the development of work from concept to completion necessitates an understanding of each visual element (**line**, **shape**, **tone**, **colour**, **texture**, **form**, **scale**, **space** and **light**) and an awareness of subtle changes inherent in application.

Critical Assessment – Why this way ... what if I?
To be selective is to engage in a self-critical dialogue. It is vital to remain open in your intention and emotions to the technical and visual possibilities that support the compositional unity and the overall quality of work. Virtuosity and fluency in application of the language come through experience, knowledge and a commitment to continuous practice.

What to concentrate on

There are two factors which will influence the finished life drawing. The first is the interpretation of the selective visual elements which need to be recognised and applied when viewing the model. The positioning may communicate the pose as being relaxed, tense, aggressive, in motion, buoyant or as having other emotional attributes which are interlocked with each other. The second factor is your own personality, e.g. a liking to work in a scale which is small and meticulous, or large and bold; whatever comes naturally to you as a maker. As a beginner there will be a searching for your own personality along with these likes and dislikes. This will become evident as you are encouraged to take different approaches in the interpretation of the pose. Ultimately your work will be identified through a recognisable **style**, developed over a period of time. Egon Schiele, Diego Rivera, Frida Kahlo, Amedeo Modigliani, David Hockney, Lucian Freud, Auguste Rodin are a small selection of artists whom, through their individual approach to the life figure, are immediately distinctive and recognisable.

How does one start?

In many books on 'how to draw the figure', a geometric analysis is applied in the initial stages of setting up the pose on paper or modelling in the third dimension. This does not mean it is a rigid box-like structure where all the physical parts are placed within, but remains flexible and changeable as the drawing progresses.

Identifying problems

The first problem is to analyse what one is looking at. The human form conveys individuality. We can identify with and recognise differences through the physical characteristics: big, small, fat, slim, young, old, male female; the model can stand, sit, lie, twist, squat, lean, etc. It has five appendages which are extensions from the torso, two arms, two legs, and a head. All five can move or point in different directions. It is flexible and capable of communication and will conform to any pose. Initially the beginner has difficulties with seeing the figure as a single unit in a specific position. Analytical

observation becomes a vital component for reasonable success. The tendency is to concentrate on the individual parts and all too often end up with either the head or the legs running off the paper. A life drawing is not a photograph. If the intention is strong enough it may look like a photograph but the process of selection by the maker can result in something very distant from a photographic likeness and still communicate the characteristic qualities of the model through intention and selection.

I would encourage everyone to experience drawing from the life figure. During my commitment to a four-year programme in sculpture, the life figure was the focus for imparting criticism directly associated with a tangible piece of work. My tutor (the late Eric Schilsky) communicated verbally on the characteristics, visual elements, and emotional attributes which were considered in relation to making the drawing or modelling more credible to the viewer.

During the last 40 years my medium has been clay and the work has covered a broad spectrum of ceramic activity – domestic pottery, garden sculpture, murals, exhibitions and installations in public and private galleries. The experience of working with the life figure has contributed immensely to my confidence in tackling visual problems of any magnitude.

The following illustrations will attempt to endorse the above statements.

Physical Stature

Before beginning the drawing, take a moment and walk around the pose. Observe the figure's physical components changing in relation to each other. The physical characteristics of the model can also be evaluated at this time. Illustration 2 (*overleaf*) conveys a large, heavy set female, seated and leaning on her right elbow. The pose is very relaxed and gives the impression that the model could retain this position for a long period of time.

The red line in illustration 1 indicates the angle of the torso and the position of change between the torso and legs. The shape of the torso, head and arms are roughly within the geometric shape above the red line and the legs in the geometric shape below. These shapes help establish positioning and proportions of the figure. The actual drawing of the geometric shapes (the red line) is not necessary as long as the figure is sketched in a manner which encompasses the entire figure without first focusing on detail (light marks within the geometric shapes in illustration 1). At this stage the drawing should accommodate flexibility in relation to positioning, before deciding exactly what the figure drawing is going to communicate. The selective process has concentrated on keeping the focus in the centre of the drawing. Even though

1

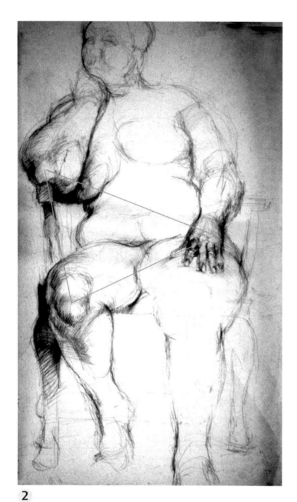

2

there is a great sense of visual support on the left hand side of the drawing (through the emphasis on the elbow, chair and knee), visually the viewer is brought back to the centre of the drawing by the hand on the left thigh. A triangle of elbow, knee and hand on the left thigh (blue lines in illustration 2) is established through the rendering of these three parts of the body.

The element of **line** is used to communicate the physical character of the pose. These lines are visually subservient to the rendered portions which make up the triangle. This is the act of **intention** which gives the drawing its individuality and vitality. Selecting the pose from any other positions would demand an evaluation of the distinctive features which would best communicate the selective process demonstrated above.

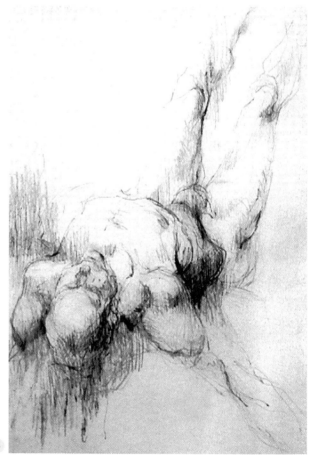

The next three drawings deal with the partially drawn figure. In illustrations 3 and 4, the expression of **tension** was the key to a successful outcome. The concept in illustration 5 is very much the opposite, depicting a relaxed atmosphere. All three are very specific in focusing on the areas which will best communicate the qualities intended.

In illustration 3 the rib cage, head and arms are over an edge of a platform or bed. There is no evidence of this support but the positioning of the figure and the extreme pulling down of the head and arms create a lift and

3

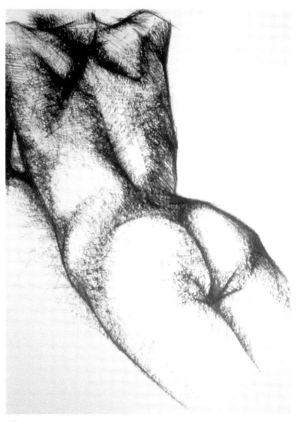

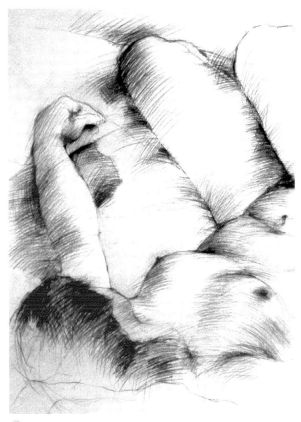

4 5

pull to the rib cage expressing an emotional feeling of acute physical tension. By the figure being partially drawn the focus is intensified in the selected area. This also applies to illustration 4 which is constructed to feel the tension in the buttocks running up the spine to the scapulas. The scapulas are pushed together through the support of the arms also implying tension.

Illustration 3 has used a suggestive approach with a loose application of line in expressing form. Illustration 4 is bolder in its containment within the outline of the pose. The contrast between rendered and non-rendered areas is used for the purpose of emphasising tension within the rendered areas.

Illustration 5 is built around a sensation of softness. This is evident in how the maker has applied the same directional lines to the figure and the surface she is laying on to create an all over unity. The visual flow from left to right has also given the work a calm and serene expression.

The reclining figure (6, *overleaf*) demonstrates foreshortening. It is obvious the **scale** of anatomical parts diminishes in size from head to feet. This can cause considerable problems in establishing the pose on paper. In illustration 1, on page 43, geometric shapes were used to evaluate the positioning and proportions of the seated figure. There are poses in which the geometric application suits the layout. In others, as in this reclining pose, a line formation can be useful **before detail is considered**. This is the biggest singular problem of working in the manner of representational realism where artistic liberties are not acceptable: If the intention is to represent what is being observed accurately, the relationship of parts to each other is very important.

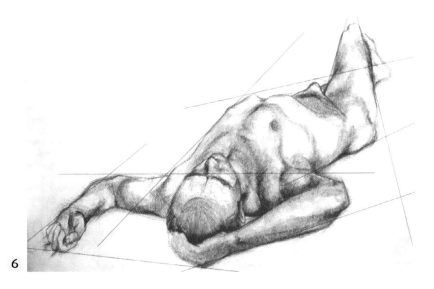

6

In drawings 7 and 8 **visual motion** is clearly communicated. The arms in illustration 7 appear to move along with the rotation of the body. This movement is indicated by freedom from specific detail. The success depends upon the artist's selective ability and physical energy in response to the motion of the figure. It is impossible to view this drawing without emotionally feeling movement, while every mark of the drawing in reality is static. Drawing 8 also depicts motion in a different way. The axis of motion focuses on the pelvic region, two torsos hinged on a single pair of legs. Visually the movement up and down is clearly evident.

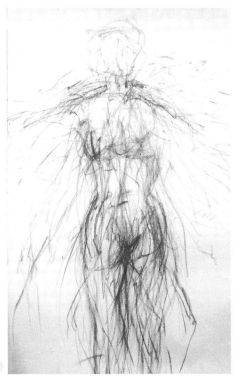

7

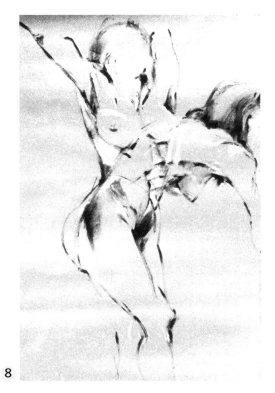

8

9

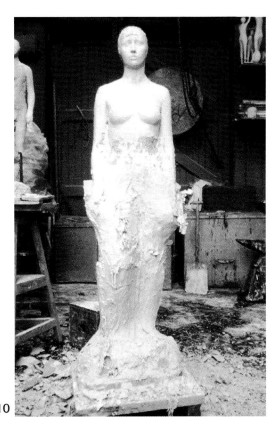
10

These two illustrations (9, 10) define the procedure of study in relation to conversion of the life figure from two to three dimensions. Two-dimensional life-sized drawings of the model were made from four positions: front, back, and two side views. This enabled work to continue when the model was absent. The sequence of development was from paper to clay and finally into plaster. The conversion from clay to plaster is necessary for several reasons. First, it enables the work to stand without the assistance of a support connected to the armature inside the clay model. Also, if the work is allowed to dry on the armature, it will crack in many places due to shrinkage of the clay. Brass strips divide the work into sections. Plaster is applied over the clay within these sections. These negative plaster sections are reassembled as a hollow replica of the model. Plaster is poured into the negative and then the negative is chipped away leaving the positive plaster model. Refining the work continues by applying additional plaster or chipping plaster away, what ever the case may be.

As demonstrated in Chapter 3, the transformation from flat to round demands an evaluation of the work within 360°. Relationships of form are continually changing through the rotation of the work. The elements of scale, space and light play an exceptionally pertinent part in the evaluation of three-dimensional form.

This brief chapter on life drawing and life modelling was not to explain in specific detail how to draw the life figure. This will only come with practice and application to the task. The purpose was to introduce the value and relevance of this experience. Through observation and interpretation, this discipline will undoubtedly enlarge the visual vocabulary, and instil confidence in the use of the figure where it is applicable.

CHAPTER 5

Personal Development: Two-dimensional

PERSONAL DEVELOPMENT DEMANDS AN APPROACH to the problem of constructing a framework for the idea to materialise. The fundamental visual elements of line, shape, tone, colour, texture, form, scale, space, and light along with intention, selection, and critical assessment, are the basic foundations which I consciously use to organise my ideas. The introduction and preceding chapters outlined my belief in establishing a language which can be used to communicate strictly in visual terms.

The idea and intention are inseparable. Organisation in relation to composition (use of the visual language) and technical competence are essential to fortify selection. Critical assessment can only be valid in the framework of comparison. This will demand a series of work based on the same theme.

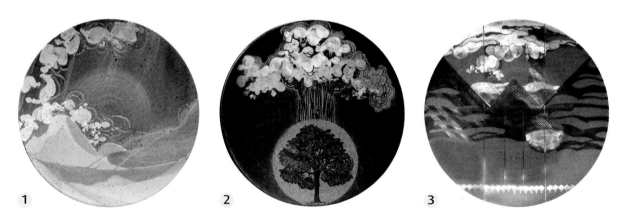

Plate 1 has a very painterly approach in creating a visual landscape within a close tonal range of colour. The inspiration came from the atmospheric qualities I observed in wintry Scottish landscapes. Plate 2, my intention was to have the viewer experience the cloud formation and the tree almost separately. 'Summer tree' is isolated from the clouds within its own circle joined together by a vertical shaft of rain. In illustration 3, the introduction of geometric figurations along with scale difference does not allow the vision to take in the meaning as directly as in illustrations 1 and 2. The introduction of straight lines and a strong horizontal movement against the diagonal set up between the small rectangle in the middle and the small circle to the right help to orchestrate the visual components. Another strong horizontal is created by the row of gold lustre trees played against the four vertical lines. Illustrations 1, 2 and 3 are of 54 cm diameter (25 inches) plates.

Relating the work to the visual elements and not giving technique equal importance would deny ideas the means to materialise and mature in quality. I have great respect for craftsmanship and the beautiful way materials are put together no matter what the medium.

For me clay is the ultimate material. It physically depends on the four basic elements to make it permanent. Earth where clay is found in abundance, water to make it workable, air for drying, and fire to make it durable. Technique must be applied to all four stages of the making for a successful outcome. My definition of technique is to understand how the material and the process work together in order to produce a finished product.

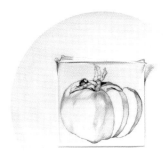 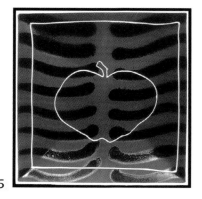 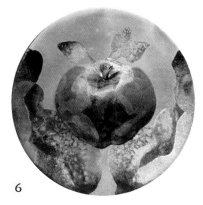

4 5 6

Illustration 4 was drawn with a black ceramic pencil. Instead of carbon which ordinary pencils are made of, ceramic pencils are made of oxides which will not burn away in heat up to 1200°C. The intention was to draw the apple in a realistic manner using rendering to give the illusion of roundness. Illustration 5 dismisses realism for an impressionistic drawing of an apple which is imposed upon a pattern of black sprayed lines giving the feeling of a rib cage. Illustration 6 was produced through the technique called **raku**. It is the most unpredictable process I use in the production of ceramics. The colour qualities are extremely variable and much can be contributed to the firing conditions. The oxide of copper is mainly used for the dramatic colour variation you see above. These plates were bisque and glazed in the normal way. When fired for the second time they were extracted from the kiln at 1000°C and covered with burnable materials like cardboard, wood chips, leaves, or anything else that is combustible and covered over with a metal container to smoke until cold in a reduced atmosphere (excluding the oxygen). This condition makes the copper change from a matt black to an array of colour. (Illustrations 4, 5 and 6 are 30 cm (12 inches) plates.)

The following five plates were made on a slab roller. This is a technique of rolling out a slab of clay, in this case approximately 24 in.² (61 cm) by ½ in. thick (12 mm). The colour palette of yellow, blue, pink, black, brown and white clays were rolled out very thinly, cut into various lines and shapes and laid on top of the 24 in. clay square and rolled in gently. (The result is similar to the technique of wood veneering.) After rolling there is no indication of layers. This is another extension of the collage method. It also has the flexibility to make changes before finely rolling the colours in.

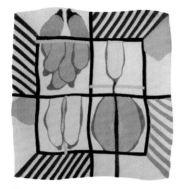

1

A

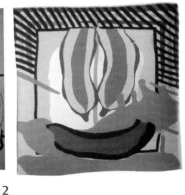

2

The drawing above (A) was the starting point for a sequence of slab rolled plates. Illustrations 1 and 2 are of finished plates. No.1 follows the drawing closely. Illustration 2 has partially departed from the drawing by introducing a totally

contrasting interpretation on the banana in the lower half of the plate. The intention was to incorporate visual direction through the use of verticals, horizontals, and diagonals. The strong black line around the horizontal dark grey

banana has formed a relationship with the black line border above, while the lighter grey bananas extend outside the suggested inner square. This has broken the symmetry which is evident in illustration 1.

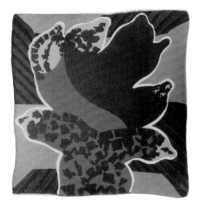

3

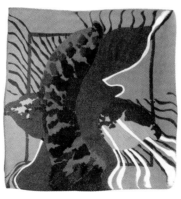

4

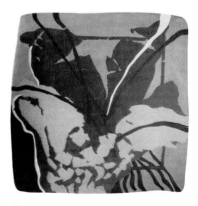

5

Illustrations 3, 4 and 5 are no longer influenced by the drawing.
 All three are radical departures and progressively much freer in

losing their banana origin. The diligence in beginning from the drawing (source material) and the use of selection and critical

assessment allows the theme the possibility of continual development.

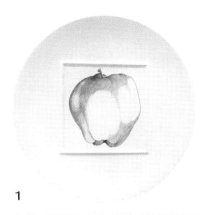

1

2

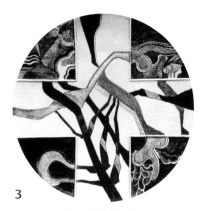

3

The departure from the single plate began to emerge through the realisation of the limitations of the square within the circle (1). It was only possible to work inside or

outside the square. Illustration 2 allowed me to work both inside and out as in illustration 3. The possibility of being able to link plates together visually, if not

physically, enabled a completely new investigation of geometric pattern applied to the plate form using the element of line alone.

The geometric figurations below show the intention of selecting a format for a series on geometric composition. The plates were all made through the slip cast technique. This allowed the geometric figuration to match up exactly with the adjacent plate.

The first step was to identify the number of figurations which would allow the greatest flexibility applied to their relationship to each other.

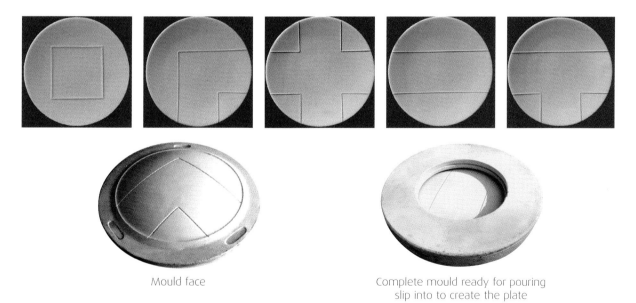

Mould face

Complete mould ready for pouring slip into to create the plate

The geometric figuration was carved into the mould face and therefore became a raised line on the finished plate as above.

This was my first attempt to relate two units, each manufactured from the same mould. These two plates use the element of line and the right angle figuration. Note the carrying over of the white and gold horizontal lines from the white plate to the black plate. This has helped to create a relationship between the two separate plates.

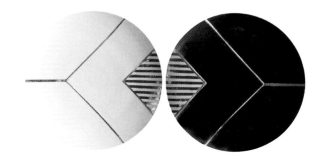

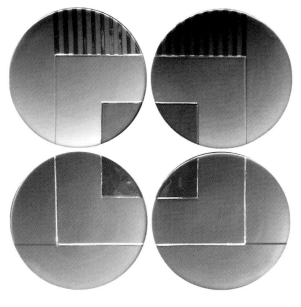

The four plates (*left*) became a logical step forward in developing the module idea. The element of shape is now used to make the inner square. The lines on the two upper plates help lift the vision vertically in order that the concentration is not totally held in the centre. The two bottom plates have a thinner horizontal line which gives the outer square a platform to sit on while the inner square is left to float. These are all conscious intentions in relation to composition.

The module idea was now capable of being expanded in numbers, but had little flexibility within its self. In the reverse side of the plate a groove was made to accommodate a wire fixture which was capable of rotation. The three compositions below, made from the same four plates, were simply done by turning the wire on the plate to the desired position.

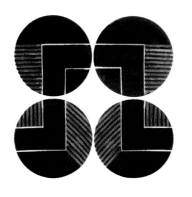
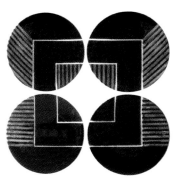
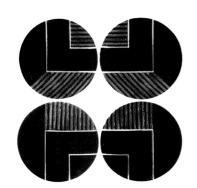

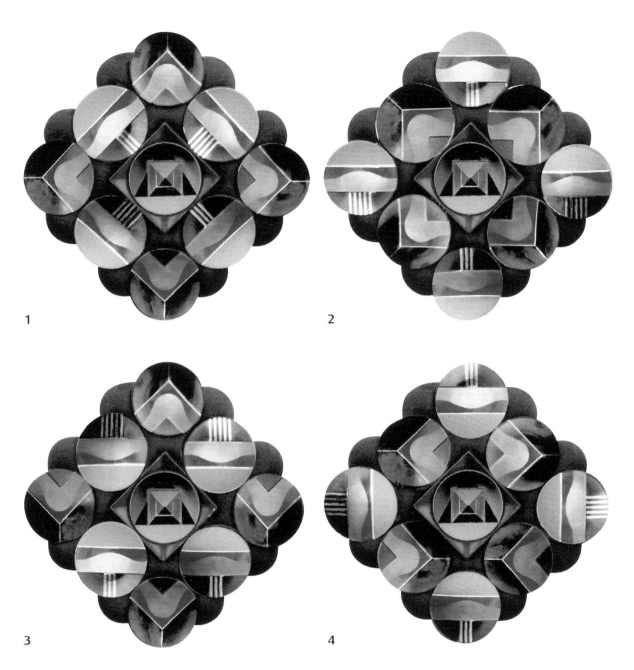

1

2

3

4

The four examples of plate variations above are clearly defined through their rotation. The diamond format has replaced the square arrangement. There are three geometric plate units, the right angle, two parallel lines, and the square figuration plate mounted on a background square plate. The centre double mounting is the only constant. The other plates may be rotated giving additional permutations.

It was the intention to devise a way of hanging the composition without each plate being hung individually, which was impractical if the work was involved in a travelling exhibition. The solution was a background of 6 mm plywood with permanent screws for the plate locations. The background itself

would only require two holes for mounting. Integrating the background with the plate composition was solved by padding the plywood with foam rubber and then covered with a matt navy blue felt material. The contrast between softness of the padding and the hardness of the ceramic material complemented each other and gave a nesting effect to the plates.

An additional technique of sand blasting was used within the blue areas of the outer plates. The intention was to create a flow within the composition to counter the predominantly straight lines. In the parallel line plates, the three and four lines within the black area are directional, leading the eye inwards or outwards. The viewer is confronted with a composition which grew out of an idea of flexibility. This was developed by being aware of how the visual element and its organisation can create visual interest and continue in an evolutionary way.

In this three unit composition (pages 54 to 56) the intention was to orchestrate the composition enabling the viewer to assess the rhythms of visual elements and their associations from one to another.

The units are shown separately in order to describe the variations and relationships within each group. All three units were assembled together forming a single composition mounted on an asymmetric plywood background.

In all three units the plate size remained constant and the figuration of line followed the pattern embossed on the plate as illustrated in the example of the four plate composition on page 52. The lines had either gold or platinum lustre which defined the figuration and directional movement within the units.

Line, shape, and colour are the three elements in varying permutations linking together all three units.

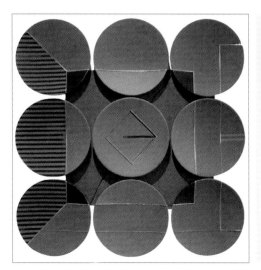

Unit 1 Visual pace is extremely important in dealing with variations of identical and modular components. The ability to rotate the plate is significant in creating variety in relation to scale and directional movement from one plate to another. A square is made from the nine plates with another square formed by the small right angle shape in the four outer plates. This established a large square enclosing a smaller square turned 45° to form a diamond with a strong horizontal line directing the vision to the right. The three vertical left hand plates with their horizontal lines fortified the movement to the right along with the two subtle lines on the middle right plate. These nine plates are the left hand component of the trilogy composition.

Unit 2 This rectangular group of twelve plates is located on the right side of the final composition. A specific movement to the left was indicated through the black diamond figuration. This was an exact reversal from the plate in unit 1. The three right angle plates created a diamond formation to accentuate the direction to the left. In order to stabilise this strong movement, a line formation gave a rotating motion to the four plates on the upper right. This also created a square within the arrangement helping to form a relationship with the other two units of the trilogy which were square formatted.

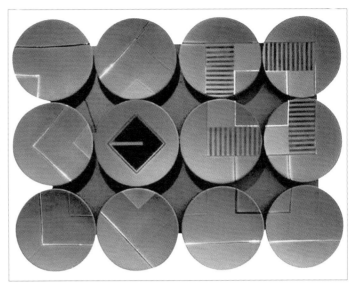

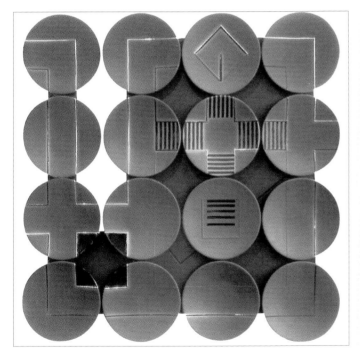

Unit 3 The middle unit comprised of 16 plates which formed a square, but could also be visually read as a vertical rectangle of 12 plates with an additional four plates to the left. This is due to the white spaces between the plates and the intention of creating a visual separation. The domination of the black square is countered by a rhythmic line leading from one unit to the other, accompanied by the pattern of line placed diagonally above.

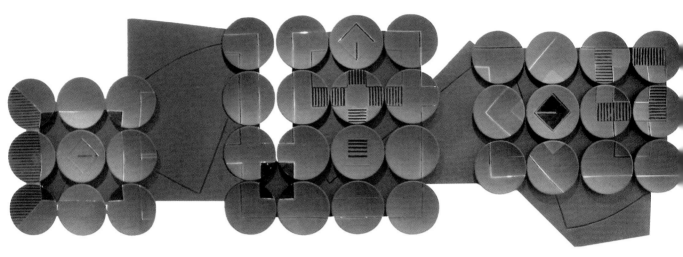

A plywood background forming an asymmetric figuration was designed for mounting the three units. This was intended to create a contrasting movement across a predominately cubic composition. The three units were also placed asymmetrical to each other. An incised line was carved within the background which gave a further movement reinforcing the unity between the groups. The two curved lines on the background add to the compositional orchestration and were important in relation to visual flow.

The attention to detail and relationships is the foundation for building a visual vocabulary that can be applied to **critical assessment** before presentation to the viewer.

The introduction of a nature theme has been integrated with the geometric patterns of the slip cast plates (*opposite, top*). The apple theme is drawn onto the plates within the geometric lines. These relate to the plates without the apple drawings. In each of the four top illustrations opposite note the lines which are outside the geometric figurations. They are important in leading the eye directionally. The conventional format of a plate is adhered to except for the half apple relief plate. This is a deliberate attempt to change the scale of the drawn apples to the modelled apple. Simplicity is combined with complexity through the application of the visual elements of line, shape, colour and scale in the organisation of this composition. A variety of permutations is possible through the turning of the plate as described on pages 52–53 and illustrated above.

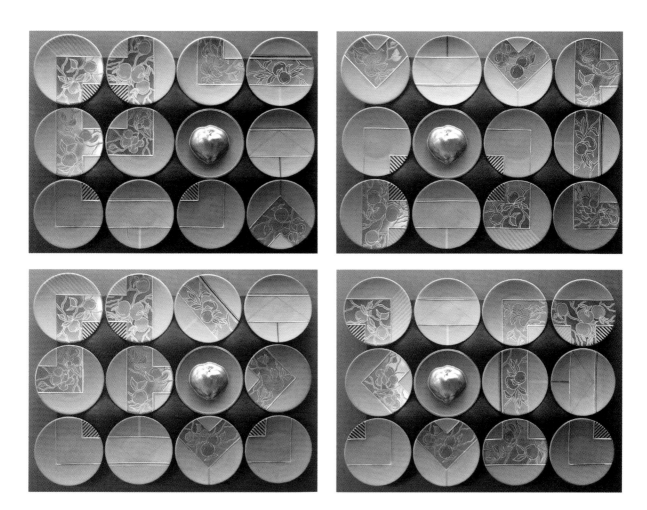

In the three square plates below, the intention is to design shapes which will flow from one plate to the other. This mainly happens in the background of the triangles. Note the three black lines within the triangles that are not directly vertical or horizontal. They are significant in changing the visual pace and also contribute to the all over unity of the composition. It is this attention to detail which will only become available through the development of a visual vocabulary.

This plate composition is titled 'Deep Pool'. It is comprised of 64 plates measuring 12 inches in diameter (30 centimetres). The plates are mounted on a box construction with the inner plates receding into the centre. Squares of light blue are accompanied by white line circular movements similar to reflected sunlight across water. The paradox of geometry in relation to water, and the representation of a pool being vertical is an extremely compelling image. The emotional association with the work is contributed to intention and ultimately how the selection of the visual elements is organised. There is no doubt that scale in relation to intention is also a vital consideration.

The title of the work below is 'Reflections'. A tree standing beside water is bordered on both sides by hill forms. 12 inch square units make up the entire composition. A rectangle set on its point gives the central unit an offset figuration. The tree and the water are not the same size but transmit the feeling of unity. The black wintry tree and green water convey a cold and still atmosphere emphasised by the concaveness of the plate shape. The convex hill forms play their part in developing a contrasting element with the feeling of fullness. The uneven horizontal lines across the convex hill forms impose a quality associated with earth. Also note there is a different number of hill forms on either side to break the symmetry. If the all over shape is visually insecure, no matter how much detail is built within, the work will fail. (This point was also expressed in the chapter on life drawing.)

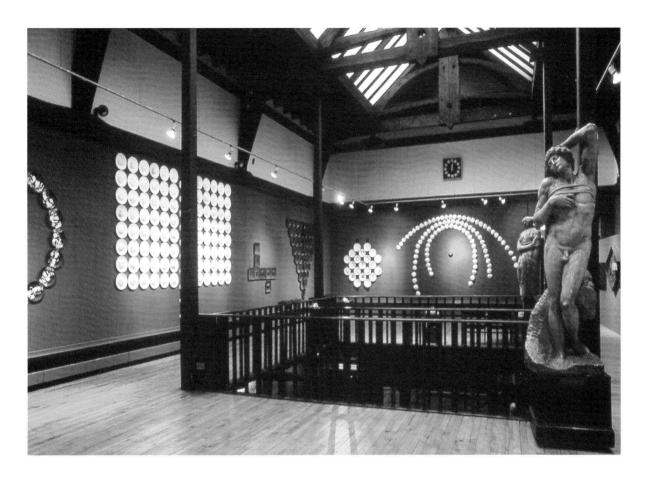

This exhibition (*above*) was held in the Glasgow School of Art, Scotland in 1993. The first consideration was the space. Before starting a project of this size, a review of light, colour of walls, viewing position and architecture needed to be addressed. The principle of hanging a work of art is to assess the scale of each individual piece and how it relates and complements the neighbouring individual pieces, adding to the design of the entire exhibition. With this principle in mind, the use of the visual language in relation to organisation will be a valuable asset. The application of the visual language in regards to its elements of line, shape, tone, colour, texture, form, scale, space and light all come into play when assembling installations as seen above and on page 60. The viewer is involved with the large shapes at first glance before looking at specific details of each individual composition. As noted previously, one does not have to be a practising maker within the arts and crafts. The visual language can be of assistance in any visual application as in garden design, window display, and specifically architecture where the selection process does not necessarily involve personal making.

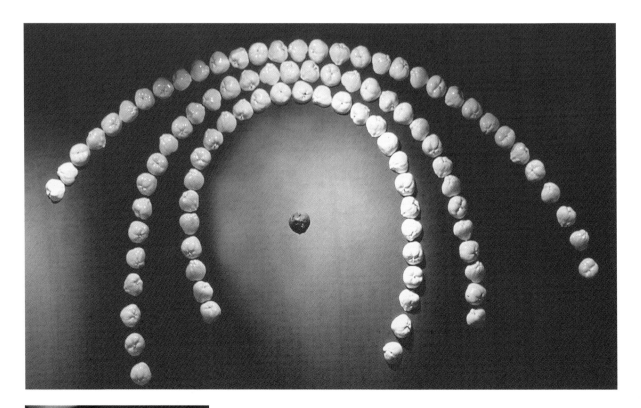

In describing the above installation, geometric figurations were accompanied by a free form composition of falling apples. It was an intended visual change of pace from the other geometric shapes. The decomposed central apple surrounded by falling apples were modelled in a way to be associated with human anatomy and emphasised through the vein like red lines. While the geometric shapes of the other compositions related to natural growth and decay, the free form composition of falling apples focused on human decay.

The elements of nature are portrayed in compositions related to earth, water, air and fire along with the four seasons. This room in the Aberdeen Art Gallery, Scotland (*opposite*) had a very stark feeling of emptiness with an extremely high ceiling. The space seemed enormous and the scale of work was of primary importance. This exhibition took a full two years to assemble. Every composition had background panels pre-fitted for easy assembly in the gallery. This type of technical consideration is paramount when dealing with a large number of individual units. The end composition in the top illustration has 126 units alone. They were all raku-fired representing smoke associated with fire. The entire atmosphere was opposite from the space in the Glasgow School of Art which has many architectural features of interest (having been designed by the world renowned architect Charles Rennie Mackintosh).

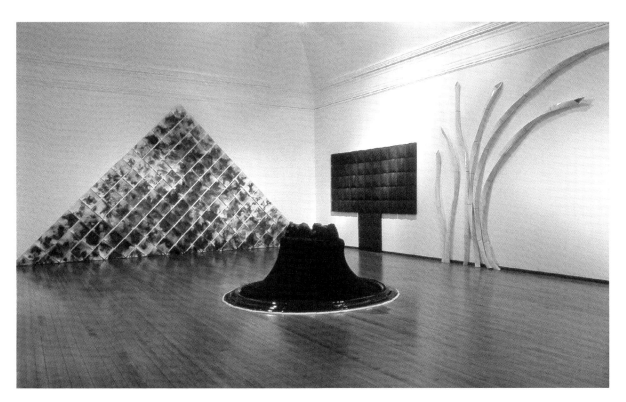

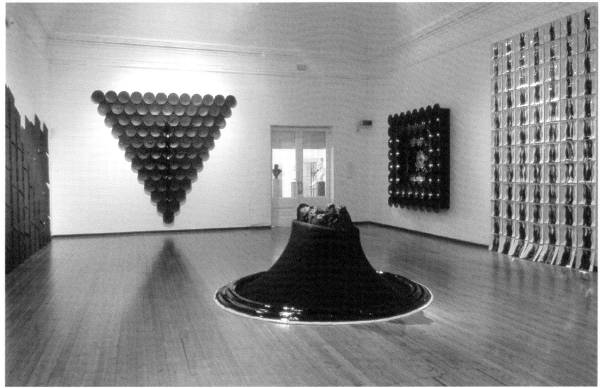

At the beginning of Chapter 5, I expressed concern with regard to concentrating on detail before establishing the all over shape of the composition.

'Spring' (*top*) has a trunk which supports the mass at the top. This may be interpreted as an abstract tree shape. Within the shape there is an abundance of detail relating to growth. The centre movement travels upwards from earth like figurations to swelling of forms indicating the coming of spring. On each side of the centre movement, there is a repeat of the upward direction. Drawn on these forms are lines in arrow formation pointing vertically.

In 'Autumn' (*right*) everything recedes downwards leaving bare stems or branches moving in the same direction. I have attempted in every illustration in this chapter to select shapes and movements which would best communicate my meaning to the viewer.

This concludes Chapter 5 on individual development (two-dimensional). The balance between technique and the idea can never be over-emphasised. Without clarity of understanding, technical competence and total commitment to the idea, frustration will prevent the accomplishment of goals which reflect individuality.

PART TWO
The Visual Languages of Specific Artists

In this part of the book, eight artists from varying backgrounds discuss how they have developed their own personal 'visual languages'. The media in which they work and the constraints and possibilities that these materials engender are an important part of the resulting way their art looks. Personal background, taste and surroundings also contribute to their vision of how they want their work to look. The importance of drawing is another theme that many of these artists touch upon.

Introduction to Part Two

'Decision-making, inspiration, beauty, sculpting, modelling, drawing, structure, process, selection, function, experimenting, balance, line, form, composition, texture, shape, weight, mass, balance, sound, light and shade, transparency, risk-taking, freedom of choice, narrative, visual language, communicate to and connect with, others; creative leap, spiritual dimension, hands-on, unpredictable, exploration, respect for materials, nature' – Vocabulary used by the eight artists represented in the following section, the same words used by the teachers of drawing.

I am a designer/maker/teacher. My first teaching post in an art college was as a tutor in basic design; the words listed were, and still are, my mantra. We teach how to look, in order to see the experience, communicate, enquire, model, evaluate, mark-make and express. Working drawings are a means to an end, a collection of lines, scribbles, marks that the maker uses to plan, rehearse, develop and test his ideas.

Drawing is defined elsewhere in this book. My contribution is to try and synthesise the values and dynamics of the act of drawing for designer-makers, applied artists and craft workers. A personal visual language is a prerequisite for every artist/maker. In the following chapters, I would invite the reader to consider how the contributors use drawing, not always with a pencil and sketch pad but equally with their chosen materials and process.

Engraving, cutting, abrading, dusting, curving, incising, playing with shape, visual thinking, constructing a picture or a story, recording of imagery on film, reference frame, rearranging, embracing place, sketch freely, using a scaled grid, simple models, scaled maquette, 'at risk', creativity, a means of arriving at a solution that can be achieved in no other way, memory, hands-on, freehand, going for a walk, 'I want to draw in the air with the glass', an abstract journey with line, colour and texture, rolling, a critical assessment of shape, line, attitude, colour, section, weight, scale and material quality, manipulated by surface treatments, chipping, converting personal ideas into individual visual statements, critical assessment, compositional organisation.

The vocabulary of making is inextricably linked with the vocabulary of drawing in its widest sense. All makers 'draw' with their materials, the space occupied by the artefact, with the object's relationship to the viewer, with light and shade, with tactility and sound.

I teach drawing 'systems' – Bauhaus techniques and methods, the golden section, Fibonacci series, perspective, rhythm. Scale, proportion, line, tone, texture, spatial forces, visual kinetics, colour theory, anatomy, contrast, analysis, measured drawing, orthographic projections etc., etc.

The ubiquitous computer-aided-drawing is already migrating from industrial product design and architecture to the crafts and applied arts. Ease of access and low cost software packages are opening up more opportunities for makers to professionally present their ideas, virtually model, cost and even rapid prototype their products. This is a useful addition to the vocabulary – not a replacement.

Makers will always draw – 'I should have to control the line, not like the driver of a car, on one plane: but like a pilot in the air, movement in all three dimensions being possible.' (Berger J. 1972)

Professor Les Mitchell, *Edinburgh, July 2006*

Reference Berger, John, 1972, *Selected Essays and Articles: The Look of Things*, Penguin, England

ALISON KINNAIRD – Glass engraver

Working with glass

The choices open to an artist are defined by many things. In my own experience as an artist working with copper-wheel engraving on glass, there are particular elements which form an important part of the decision-making process.

The medium

The medium in this case, has such a strong character that it cannot be treated simply as a 'blank page'. It makes many choices for the artist, but opens others to you. These choices and the character of the medium must be respected if the work is to be successful. The positive aspect of this is that often an idea will be inspired by the medium itself.

Glass has very special and seductive qualities. It can resemble ceramic, metal, stone or textile. It has the character of water, air, fire and ice. It traps light in prismatic colour or mirror reflection. It can distort or obscure or form an invisible barrier to protect or to separate. It has a purity and a spiritual quality unlike any other medium. It has opposing natures – hot and cold; smooth or razorsharp; seemingly weightless as a bubble yet heavy as lead. It can have jewel-like colour or allow the frosted white of the engraved images to float suspended within the glass.

The technique

Engraving, too has an intrinsic beauty. It is difficult to make an ugly cut, though the word itself suggests a crude and cruel process. The techniques of engraving, of which there are many – wheel engraving, cutting and etching, drill, diamond-point or sandblasting – all involve breaking the surface of the glass. The choices are numerous. The medium is beautiful. The techniques produce results which are almost invariably pleasing. The danger in all this beauty is that whatever one produces will be simply decorative. Beauty easily subsides into prettiness, and that, ultimately, is cloying for artist and audience. I find that the challenge as an artist engraving on glass is to produce work which is strong visually, challenging intellectually, and satisfying emotionally.

The technique with which you express yourself is very important, and will dictate many of the choices that you make. Wheel engraving is best for small-scale work, built up from oval or rounded forms, or series of detailed lines. I love the sheen of skin and the subtlety of musculature that the fine engraving grits can produce. Indeed, I think it is impossible to achieve these effects in any other way.

When you use any technique, it is important to use it in the best and most effective way. Other techniques have different strengths – sandblasting is wonderful for delicate shading, textures or repeated patterns. Acid etching is superlative for the fluid and delicate line. Diamond point uses the play of light on surfaces to produce a dusting of tiny stippled marks which appear and disappear as they are exposed to light. The technique should be chosen as the best to do the job. Technique, however, can always be stretched to produce new effects. It is always possible to be innovative, even within what is seen as an established tradition.

The subject

I choose to work with the human figures. Many artists are inspired by nature, and they produce lovely work. I find that if nature is the subject, my own work becomes decorative and sweet in a way that I do not like. Using the human figures, I try to say something that others can relate to – to express a feeling visually.

I have sometimes tried to clothe the figures. No style of clothing looked right – modern clothes look fashionable and soon dated. Classical draperies looked 'classical'. The figures remain obstinately naked. For me, this adds a timelessness and a universality to the figures, which allows them to represent common feelings and tensions. For the same reason, I choose not to put detail into facial features. It would introduce too much personality, so I leave the faces blank. The purity of the glass itself lessens the sexual element, although the naked figures are often deeply modelled.

In figurative engraving, one is actually sculpting – creating the impression of a three-dimensional entity. It is very important to understand the principles of anatomy – what is going on under the surface. Modelling is built up using simple masses to give the underlying structure, and subsequently working over these basic shapes to link them together and to define detail, either realistic or abstract.

Examples

1 Eostra (*below, left*) The strong shape of the glass triangle dictates the pose of the figure 'trapped' within it. The body of the woman is strongly modelled with deep engraving. The matte white surface of the engraved form is in strong contract to the purity of the clear glass around it. The sphere of solid crystal at the tip of the triangle puts a 'full stop' at the end of the long downward slope. The half-frosting of the globe emphasises the dual nature of the glass – both solid and liquid.

2 Sampler (*below, right*) Explores the many variations possible when depicting the human figure. Deep engraving and polishing give the white or clear modelled areas. Some figures are realistic, some have chosen elements exaggerated and some are simply outlines or negative silhouettes of figures. Using the different effects which are unique to your technique and discovering the variety that this opens to you, is an exciting exercise.

3 Making a Mark (*overleaf, top left*) From earliest times onward, people have wanted to leave their mark on the world. So the engraver marks the pristine surface of the crystal. The muscles of the figure's back are exaggerated into a stylised pattern which is recognisable, but not necessarily realistic.

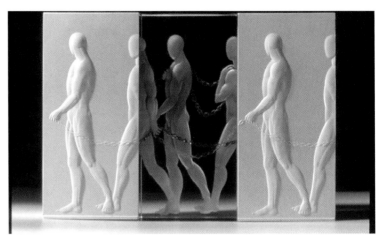

4 Chain (*above*) The central block of crystal has been deeply engraved on both sides with walking male figures. The muscles have been simplified and stylised into a satisfying pattern. The blocks on either side have been cast in resin from the surface of the engraved glass, and the glass subsequently re-engraved to change some elements. This piece contrasts the apparent freedom of those figures in the glass, with the opaque solidity of those in the white resin blocks.

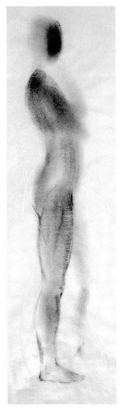

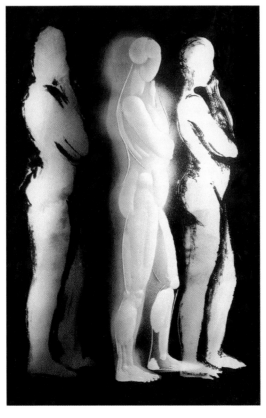

5 & 6 Figure study (*left*)

5 Sketch The initial drawing is a simple blocking in of the basic forms, with chalk dusted onto the paper and spread with a finger. This process is completely unlike the careful, tiny repetitive movements used in wheel-engraving. One stroke of the hand is enough to define the shapes and give great expressiveness and solidity with a single movement, sweeping round the curves of the body.

6 Engraved panel Interpreted in 3 different ways in glass, I made choices as to how much detail was necessary. Different resists for the sandblasting give a range of texture and variety in the brushstrokes with which they were applied. Engraving picks out important lines or solid forms and attracts attention by trapping the light in these.

7 & 8 Sketch & finished engraving 'Point of Entry' (*right*)

Engraving focuses the viewer's attention on the expressive hands, by depicting these in detail. The choice is often 'how much to leave out', rather than 'how much to include'. As confidence in drawing skills increases, it is possible not to be so explicit, to suggest forms, rather than showing them literally.

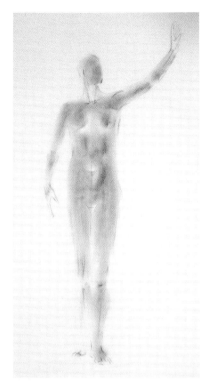 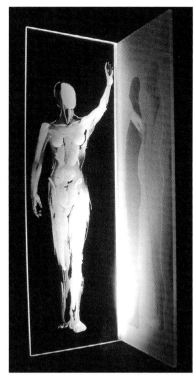

9 & 10 Sketch and finished engraving – detail of 'Psalmsong' (*right*)

The same pose is interpreted in a number of different ways. A single line can change the emotional character of a figure. Different details are picked out in the relief of the engraving, but the artist is always aware of the underlying anatomical structure.

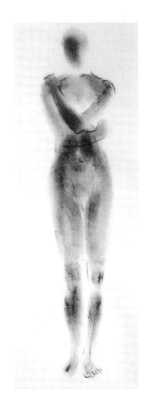 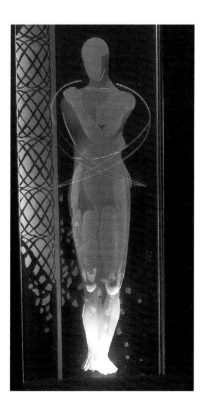

 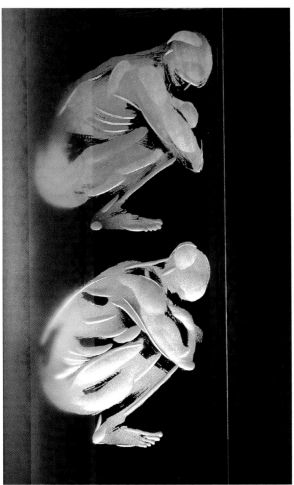

11 & 12 Sketch and finished engraving – detail of 'Psalmsong'
Again the simple, soft blocking-in with chalk is highlighted with a few lines to define the detail. The engraving may choose different ways of presenting the structure, because you are working with sculpted mass, rather than a line, to show the figure in three dimensions.

GRAHAM STEWART – Silversmith

I am a silversmith – a designer and a maker. I have been running my business since 1978 and before that spent many years learning my craft, first from my father, then at art school followed by various informal apprenticeships. My learning never ends; it is integrated in every day and every project. In writing this essay I have learned much about myself and my work – mainly by considering, under-standing and distilling my design and making process. Daily I must consider 'what am I to do, how am I to do it and why this way... what if?' All along I have naturally applied this methodology to my work. I've taken this process of intention, selection and critical assessment for granted, even though I must put these considerations to task with each and every project. Being reminded of it, I am pleased to find just how precisely and simply this visual language applies to my work.

The success of a piece of silver is dependent on this process. And what joy there is in producing some-thing that 'works'. That is, when the outcome, a well made, beautiful form, becomes an 'outward reminder of the changeless principles behind it' (D.M. Dooling, *A Way of Working*). Line, shape, form, rhythm, proportion, etc. all come together and 'sing'. There is something bigger being represented here and we recognise it when it happens. One of my favourite lines written by Seamus Heaney is: '... and that moment when the bird sings very close to the music of what happens.' I find it amazing that as artists, designers and makers, we can, through our work, often summon this magic.

As a silversmith, the initial 'intention' of a work is usually dictated to me by the person commission-ing the piece. Obviously, its function and place in the world need to be considered. I'm often called upon to make silver that marks a commemorative occasion – from large scale to small. I must somehow incorporate the importance of the event into the piece as it will become a symbol that is passed down through the generations. My client has already invested the yet unproduced piece with importance. My task is to make the finished product worthy of this importance as well as my own aesthetic requirements. It must, therefore 'work' on many levels.

Above Two bowl forms, sterling silver, engraved interiors, 200 mm diameter. Photographer Shannon Tofts

Right Tall jug, Britannia silver, height 300 mm. Photographer Shannon Tofts

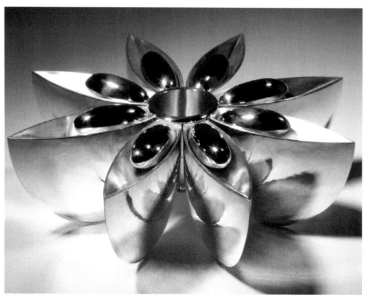

Above left 'Seed Pod Vessel', sterling silver, gold plated interior, 250 mm. Photographer Shannon Tofts. Private collection

Above right 'Seed Pod' table centre, sterling silver, parcel gilt, approximately 500 mm dia. Photographer Shannon Tofts. Private collection

Left 'Barley Stook' beaker, Rabinovitch Collection

I love and appreciate nature, sensuous forms, the fields and furrows that surround my home. These things fill me with wonder. It is this wonder that fuels my desire to make beautiful work, to come close 'to the music of what happens'. I am moved by poetry and words. I enjoy the simplicity of early folk art. I have a special interest in fine lettering – a result of being taught as a schoolboy, the proportions of Roman capitals by an inspiring teacher. I like simple things – clarity. All of these things inspire, inform and nourish my work. They become an essential ingredient of intention – a starting point.

The longer I design and work with metal, the more I realise that my work is a tiny layer on a huge sediment of tradition. Much of the techniques my team and I employ in the workshop are centuries old – the methods and tools remain the same. At the Smithsonian, I recently saw some Iranian smithing from 700 A.D. that I had never seen before. I was excited to see that the work was made by the exact techniques I was then demonstrating to the public at the Institution's Folklife Festival. It is incredible to be part of such a long tradition. But, my challenge and intention is to make use of this tradition and 'language' to create an innovative, contemporary vision.

I was recently asked to make several very special commemorative presentation pieces of silver: my remit was to make them celebratory and impressive. The first was to be a presented to H.M. the Queen on the occasion of her Golden Jubilee. In considering this project and the intention of my client and myself, it was crucial that the piece be important (i.e. large) and full of light. How fortunate that I can incorporate gold into my work and what resulted was a 15" bowl with a gold-plated interior. Central to the design was the hand-engraved words of an ancient Celtic blessing. The words spiralled toward the centre, decreasing in size in proportion with the spiral. The letters, tall and compacted in upper case, radiated from the centre point, creating, with the curvature of the bowl, an optical sunburst effect and golden glow. This indeed worked very well in fulfilling our intention – a finished product worthy of this big event.

Hand engraved silver bowl, gold-plated interior, 380 mm dia. words from ancient Celtic blessing. Presented to Her Majesty the Queen by members of the Caledonian Club, London, Golden Jubilee gift. Photographer Shannon Tofts

Another bowl, commissioned as a gift for the British Embassy in Washington D.C. to commemorate 'Scotland at the Smithsonian' and the 37th Annual Folklife Festival, fulfilled its remit and intent as a celebration piece of a very lively, and very Scottish event by again using engraving and lettering. But this time, on a wide brim of a shallow bowl, the eye is taken around the brim by a spiral of lettering to the centre. This inward movement is counterbalanced by two engraved radiating whiskers of barley which spin light across the furrows of engraving. This swirling movement and the overall effect of the bowl seems to work well representing this wonderful festival. I really like using calligraphy in my work. Once in conversation with the fine calligrapher and stone cutter, Richard Kindersley, he described this use of lettering as 'visual onomatopoeia'.

Bowl for British Embassy, Washington D.C., Britannia silver, 300 mm dia.

For me, the selection process normally begins with drawing. I find the value of this exercise immense as I can work through most of the possibilities with a line. I usually start with a curved line. The silver comes to the workshop as a flat sheet – the equivalent of a straight line. It is the basic decisions of how we will curve and cut the sheet to form a vessel that takes up a bulk of the decision-making process. Now, with my drawing, things start to get interesting with the placement of the consequent line – will it be concave or convex in relation to the first line? I must consider the angle of intersection, its flow and rhythm in relation to the first line as well as the effects this produces visually and functionally. In my mind, the drawing takes on volume, weight, what is two-dimensional becomes three. Throughout this process I must consider how makeable this piece will be, what the costs will be (do they fit the budget of the client?), will it function efficiently? Is it attractive, does it fulfil my intention, does it 'work'?

Fortunately, I can answer most of these questions with a drawing. I recall seeing similar drawings, exquisitely incised on slate by early Celtic metalworkers at an exhibition called 'The Work of Angels' at the Royal Museum of Scotland and it was moving to witness through these craftsmen's notations that their thought processes were so similar to my own.

With the high cost of my materials, experimenting does not come cheaply but sometimes the production of prototypes in silver is essential. Also, in the workshop there are always 3D forms in metal or wood in progress so we can play with the shapes, work up a few prototypes and then continue on with the finished product sometimes making changes as we go. One such project finally came to a fine conclusion only after many years and several attempts of exploring the design concept.

Möbius bowl, sterling silver, 360 mm dia. Photographer Shannon Tofts

Pair of sterling silver claret jugs for Millennium collection, Bute House, Edinburgh. Photographer Shannon Tofts

The concept started from a telephone conversation with an architect friend about the mathematical form of a one-sided continuous surface, formed by twisting a long, narrow rectangular strip through 180° and joining the ends: the Möbius strip. My early attempts at a design were unsuccessful. But, several years later, still fascinated by working with this concept in silver, a bowl evolved with two interlocking Möbius strips around the brim of the bowl, forming a gentle visual conundrum which has no beginning and no end. Redolent of the movement of water, the strips take your eye around the piece on a more interesting route. Getting to this point of the work was a fascinating journey, one that involved many hours thinking, drawing, and experimenting with prototypes.

This process of selection is intertwined with the all important self-dialogue; critical assessment, a crucial element of the design process. One project that I took on seemed to flow effortlessly from brief to conclusion mainly because all the right questions were asked during that progression. The answer (final product) is a result of problem solving during the design and production stages. I was invited to make a pair of claret jugs for the First Minister's official residence, Bute House, to celebrate the Millennium. As usual, I started by drawing vessel forms, gradually stacking various geometric elements to build a tower. This formed the body of the jug. The handle and spout were resolved in one sweep which outlines the dominant convex curve of the body. The inlaid cairngorm (citrine) at the base of the handle acts as a visual punctuation mark. Stability was an important consideration for these jugs so a low centre of gravity was established. Ease of pouring was also crucial and the wedge form of the handle allows for easy lifting. The form of the lid conceals a very functional hinge and makes subtle reference to the architecture of the new Parliament building. The erect spout and the angle of the lid, from certain angle suggest the lines of a merganser, a bird I see regularly where I live. All of these things came together to form a satisfying finished product, fulfilling its brief, yet once again arising fresh and new from an old tradition.

'Three Vessels for Three Words', raised and engraved sterling silver forms mounted on pearwood block, 600 x 290 mm. Photographer Shannon Tofts

Another Millennium commission came from the Scottish Gallery to produce a piece for their 'Scottish Gallery Collection 2000' exhibition. This commission was unique as I was not given any specific requirements for the work. I was free to enter into the project with no intention other than to futfil my desire to create a work that contained that 'magic' I mentioned earlier. A piece that would res- onate with me, be exciting, a bit different, and a joy to make. Ultimately, it fulfilled all of these things. The last three words from Seamus Heaney's poem, 'The Rain Stick' became my inspiration to make three vessels to contain them. 'Listen, now, again.' I requested permission to use the words and was pleased to be granted it. I wanted to move away from making thin edged bowls. I also wanted to move away from circles and towards more oval forms. The result was a far more solid, double skinned form with large, smooth boulder like convex surfaces. The tops of these appeared to be hol- lowed out to reveal the words. Much thought was given to the proportions and shapes of these three unique vessels. Their placement and relationship to each other was crucial in terms of the negative space around them which, rather than creating tension, created comfort. The bowls were mounted on a pear wood plinth by way of a simple socket. The end result was a gentle, contemplative piece of domestic sculpture, that asks a bit more of those who look at it. The end result was also a very happy silversmith who, with the help of intention, selection and critical assessment, managed to make a piece of silver, 'sing'.

Opposite The 'Three Honours' sculpture, commissioned by the Incorporation of the Goldsmiths of City of Edinburgh and presented by Her Majesty the Queen to the Scottish Parliament on the opening of Holyrood, 2004. Silver parcel gilt and rock crystal on Kemnay granite base. Photographer Shannon Tofts

JACK CUNNINGHAM – Jeweller

Where do 'ideas' come from? This is a reasonable question to ask of any artist or designer as it is an area that harbours some mystery, especially for those not directly engaged in creative activity. The work we see in the public domain is the end result, the sum of the parts. However, it is the process of making, or journey, the artist has made that offers the greatest insight. Formal education in the field of art, design or architecture may well embrace topics such as colour theory, the golden section, the classical orders, perspective, etc., in addition to emerging areas of information technology, our understanding of haptics and virtual reality. Fundamentals such as balance, form, composition and texture, come with their own spoken/unspoken rules and conventions. It is often our knowledge of these elements, and consequently how we break the rules, which is most interesting.

If we examine theories of creative behaviour, many factors contribute to the debate of what constitutes a creative individual and what strategies and techniques may be employed to stimulate creative outcomes. For the fine artist there are perhaps fewer boundaries, or at least only those that are self-imposed, allowing free reign to personal expression. Conversely, the designer, in addition to aesthetics, often has to respond to a brief or address such issues as: function, wearability, performance. However, one could generally argue that creativity is about risk taking, making connections, novelty and generating new, previously unknown solutions, about '... linking these new ideas to restraints, grammars and rules, and of course to reality' (Landry & Bianchi, 1995). There is considerable volume of existing research on the cognitive processes at work during creative problem solving. Also material that explores how as an educator one may foster creativity in others, how educators may nurture a creative environment, or indeed, how we quantify a creative act (e.g. Isaksen et al., 1997; Bailin, 1994; Ghiselin, 1985).

An appropriate and supportive environment or climate, where obstacles are removed, clearly plays an important part in our ability to respond creatively as individuals, with defined characteristics such as 'openness' and 'freedom of choice' (Cole, Sugioka & Yamagata-Lynch, 1999). That said, a creative environment might well mean different things to different people. Also, a workplace environment is quite

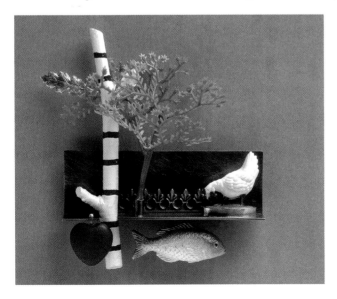

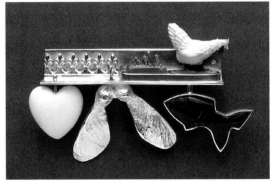

Above 'Dear Green Place' (Series 1)
White metal, obsidian, chrysophrase, readymade.
80 x 50 mm (Photo: Graham Lees)

Left 'Dear Green Place' (Series 4)
White metal, carnelian, wood, paint, readymades.
80 x 90 mm. (Photo: Brian Fischbacher)

different to our home surroundings, where different possibilities, constraints and limitations come into play. We can generally accept, however, that in addition to meta-cognitive activity, creativity is a 'behaviour resulting from the interaction of the person and the environment' (Schoenfeldt & Jansen, 1997).

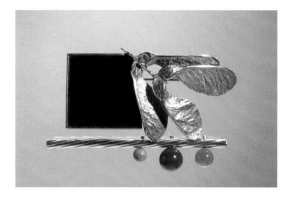

Central to my own creative output, that of a contemporary studio jeweller, is a strong thematic based on subjects such as memory, childhood, relationships and the familiarity of place – this being my response to specific environments and locations. This output is a reflective response to physical and emotional experiences. Aesthetics, and our response to them, are of course, a matter of personal taste. My particular aesthetic is developed from that personal perspective and sourced during numerous visits to countries such as Japan and the influence of time spent between homes in Glasgow and Paris, '... the creative person and the environment'.

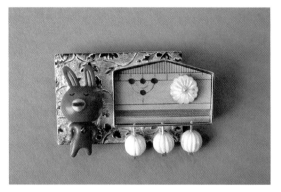

My jewellery could be described as narrative. In developing a visual language through the use of icon and imagery, I have concentrated on the brooch form as the vehicle to capture and reflect these feelings of universal significance. The brooches are compositions of small objects that may or may not have particular meaning on their own. However, when assembled in groups, within the context of a title, it becomes possible for one's imagination to construct a picture or story that has a certain personal recognition.

It may seem unnecessary, even pretentious, to categorise and pin down types of jewellery by investing it with meaning, as though by doing so, it will alter or change that way we look at it, or indeed how we

Right, top to bottom

'Midnight Blues' White metal, lapis lazuli, agate. 75 x 40 mm. (Photo: Andy Stark)

'A Very Japanese Thing' White metal, readymade, bamboo, mother of pearl, coral. 80 x 80 mm. (Photo: Jack Cunningham)

'The Peak' White metal, jade, aventurine, rock crystal, obsidian. 85 x 60 mm. (Photo: Graham Lees)

'Journey' White metal, coral, sponge coral, jasper, gold leaf. 75 x 40 mm. (Photo: Graham Lees)

Above 'Osaka-jo' White metal, rock crystal, marble. 85 x 50 mm. (Photo: Andy Stark)

Left 'Memory Kit' White metal, wood, glass, bone, moonstone, shell, coral, plastic (readymade). (Photo: Jack Cunningham)

might enjoy wearing it. After all, does not all jewellery mean something to the maker and wearer? However, the narrative jeweller, in my opinion, sets out to do exactly that. It is designed to communicate, often without ambiguity or arbitrary intention. A definition of 'narrative' jewellery, a genre within the wider framework of contemporary body adornment, may therefore be described as: 'A wearable object that the maker has the deliberate intention to communicate to an audience through the use of visual representation, which contains a comment, story or message.' Strong motivational factors in the production of contemporary narrative jewellery would indicate that makers seek a response to their work through a need:

To comment on the human condition through personal, social or political observation.
To communicate to, and connect with, others.

A piece of narrative text may be seen as a journey from A to B. Simplistically, it has a beginning, a middle and an end. No such journey is made by a piece of jewellery. It is intact, self-contained and may not even offer the assistance of a title which could allude to its 'content'. However, neither is it merely one-dimensional. It is the audience, the viewer, who continues this journey by connecting with the work through cognition, memory and interpretation, thus completing the narrative sequence.

My own working process, or design sequence, involves exploring a number of interconnected factors and activities. The use of a sketchbook (drawing), the recording of imagery on film (source) and the use of text (context), each play a part in generating a narrative based on personal emotions and experiences. Most designing is carried out in one's head, where images can be rotated, altered and edited before committing to paper. The sketchbook is a tool for recording these 'ideas', while external stimulus, source material, contributes to the overall frame of reference. The context, indicated by the title of a piece, is the useful key, the point of connection and springboard for the viewer's imagination to make his or her own journey. It is often the case that rather than creative leaps, small incremental design developments are made with each new piece, which builds on previous ideas and notions, what Blackburn refers to as 'the scaffolding of our thought' (Blackburn, 2001). These changes may at times seem quite radical to the viewer, and at others there is a recognisable continuation of previous themes.

A parallel activity of my studio practice is to arrange a wide variety of objects, fabricated or found, in a position where they will be viewed frequently. Over a period of time connections are made by rearranging these objects over and over until each artefact has established something to say and has found its partner. Research and the pro-active gathering of source material generally inform the work and one is constantly attuned to the potential of the everyday, the unexpected, even the mundane, which may play some part in a future piece. In addition, there also exists a certain lack of control, equally important during this period, allowing a degree of chaos and uncertainty to interplay and determine the final outcome of each brooch. Whether so called creative individuals have an intuitive instinct or innate ability is debatable. What is certain is that creative problem solving requires a driven, searching approach to information gathering, a strong sense of enquiry and openness to possibilities.

As with other areas of art and design, narrative jewellery tells us something of the designer maker, who thereafter may remain quite anonymous. It is the wearer who then becomes the vehicle whereby a wider audience engages with the work. For the wearer there exists the potential to re-interpret the work and through this personal interpretation, there is empathy and interaction. As Moignard says of my narrative '... it feeds the work into a relationship with the wearer's view of it, which may be a long way from where it started' (Moignard, E., 2003). The desire of the wearer to make his or her own personal statement is significant, as it enables the wearer to become part of this process of communication, a part of the history of the piece. A triangular relationship is therefore formed: maker, wearer and viewer. Narrative jewellery perhaps demonstrates this triangulation most overtly given that the artefact is physically carried with the owner, endorsing the prime component of narrative work, to communication with others.

Top 'Pére Lachaise' (Series) White metal, wood, paint. 90 x 70 mm. (Photo: Jack Cunningham)

Above 'In The Garden' White metal, cultured pearl, coral, wood, paint, moonstone, found object. 80 x 70 mm. (Photo: Graham Lees)

References

Landry, C. and Franco Bianchini, *The Creative City*, 1995, Demos, London, p. 19.

Cole, D.G., Sugioka, H.L and Yamagata-Lynch, L.C. (1999), 'Supportive Classroom Environments for Creativity in higher Education', *Journal of Creative Behaviour*, 33, p. 277.

Schoenfeldt, L.F. and J.K. Jansen (1997), 'Methodological Requirements for Studying Creativity in Organisations,' *Journal of Creative Behaviour*, 31, p. 73.

Blackburn, Simon (2001), *Think*, OUP, London, p. 4.

Moignard, Elisabeth (2003), *Jack Cunningham – On the Line*, p. 14.

JOHN CREED – Metalsmith

Fundamental principles

My approach is to use the minimum of material to achieve a concept. I seek to establish a purposeful interplay, physical and visual, between viewer/user and the work, where many of our senses can respond through the appreciation of shape, weight, mass, texture, balance and sound. The motion of a gate, for instance, its handle and sound, should embrace the user in a pleasurable experience. The work is more than its visual impact, it becomes relevant to its place in the world by its human and spiritual dimension. As a craftsperson the intuitive and sensitive handling of the material is the essence for me, and ideally, designing and making become one.

I am a designer and a maker and work in two distinct areas:

1 Commissioned work serving a purpose
 and
2 Experimental or individual expressive work.

The first embraces the public domain of implanting commissioned work as part of an environment where the work becomes attached to whatever exists. Here I act as the 'servant' of society and therefore have a responsibility to our heritage as well as the immediate application of usage and visual statement. The work becomes part of the architectural or natural landscape.

The design process starts by embracing the place or site of the intended work by considering history, geography, architectural style, materials, solar orientation, size. The client, as a working partner, has influence, and immediately impacts on the outcome with a 'brief', or purpose of the work. Intended human, animal or natural usage usually has to be considered. Statutory requirements of disability access, fire regulations, vandalism and strength need to be integrated.

This preparatory assessment is crucial before visual imagery begins. A visit to the intended site is essential to experience a feel for the space. Ideas will evolve out of this and become rooted to the place. It must belong there and feel right. From this, concepts will emerge and imagery occur to express these. My own work philosophy will kick in and drive the design forward. For public projects the artist is often part of a team where success is dependant on creative collaboration from concept to completion, with client and architect especially, and also structural engineer and project management applying their own expertise.

David Pye distinguishes between a) 'the workmanship of certainty' where quality is assured before making, as in quantity production, and b) 'the workmanship of risk' where the quality of the result remains at risk during the making process, as in singular and experimental work (in *The Nature and Art of Workmanship*). I find that some commissions demand the discipline of this 'workmanship of certainty' and others leave more freedom for 'workmanship of risk'... There is often an overlap and the working methodology will differ accordingly.

I shall use two case histories to illustrate my working methodology.

Usher Gallery, Lincoln, England

Project: to design and make a pair of main entrance gates and railings to enhance the building and its surroundings.

This stone and brick Gallery stands on a slope below the Cathedral facing a busy, steep road. Built in 1927 using the bequest from a local jeweller, it houses his collection of miniatures, porcelain and paintings and unique selection of watches.

The main considerations of mine in evolving the design were as follows:
- to harmonise with the undulating landscape.
- to use elements in the design which make reference to the Gallery and Cathedral above, particularly the cathedral's lancet arch.
- the view of the work from all the different levels of hill and road.
- scale in relation to the existing columns and the human figure.
- physical and visual integration with the brick columns and existing fixing points on the stone coping of the existing base for the railings
- budgetary constraints.

Concept

At this stage it is necessary to visualise the broad intent of the idea.
- I decided that the overall concept should be formal, as befits the Gallery's status within the city.
- it should create some 'softening' to the rather imposing Gallery, i.e. an undulating movement which would echo the topography of the Gallery precinct.
- there should be emphasis in the design using fine detailing of the joints and hinging, and some gilding. The watch collection is referred to with the use of stainless steel roundels and as a jeweller highlights of gold leaf. The work should be made completely by hot forging using traditional blacksmithing techniques in order to relate to the benefactor jeweller and craftsman.
- reference should be made to the principal characteristics of the Early English period in the nearby architecture, which used pleasing

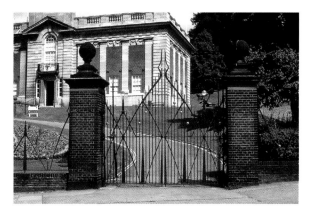

Top to bottom

Entrance Gates with Railings, Usher Gallery, Lincoln, 1995, height 4 m. Scaled maquette and drawings of competition entry

Usher Gallery. Gates half open to admit pedestrians and bar vehicles

Usher Gallery. Gates closed

proportions, well-defined outlines and simplicity in ornament. The shape of a lancet arch was taken from the Cathedral as a general motif. It meant that the technique of 'drawing out', reducing and changing the shape of material along its length during hot working, suited the concept.

- the impact of the gates as a threshold is important. They are designed to be locked in a 'half open' position; to restrict access to pedestrians and indicate the gallery opening hours.

Design development

From concept, ideas were sketched freely and developed sometimes using a scaled grid. Simple models of parts of the design were made to aid three-dimensional understanding.

The whole design was then drawn to scale. The visual connections between parts that make up the work were essential to arrive at a coherent and consistent design. The skill now is to represent and communicate the idea to the client and advisors in such a way that understanding and comprehension of the concept are made accessible. For large projects and when in competition with other designers for a job, I usually use a scaled maquette which shows the work in relation to its placing. A three-dimensional form explains the work spatially. Examples of materials, surface finishes, special techniques are also necessary to show the client at this stage. The development of work, after being awarded the project, will require careful adjustments to embrace visual, technical and cost requirements, as well as complying with safety and disability needs without compromising the idea.

Making

The total work was hot forged using primarily a power hammer. All parts were placed in the fire, often a number of times, and then shaped by hand. All 150 holes were 'drifted' i.e. punched and opened out without cutting away material. No section of the piece is exactly the same and of the original manufacturer's section. Everything, apart from the gilding and galvanising, was made and finished in my workshop. With this work, every small nuance in the metal and reappraisal of design, during the making process has been consciously shaped and adjusted by the craftsman: just as a brush-stroke implants individuality to a painting. The whole work was fully hand crafted and whilst being made was always 'at risk' (David Pye) in its quality of outcome

Borders Regional Council Headquarters, Newton St Boswells, Scotland

Project: Main Entrance Gates for new extension.

The context is totally different from example 1, but the main purpose is the same - to create a threshold. However, the work should also act as a security screen and be seen as a 'logo' to the status or activity of the institution it is attached to. The style of the existing architecture is uncompromising. The first impression is graphic, strongly linear, where colour punctuates the surface. The work will be physically and visually part of the building but has to be developed as 'an after thought' to the whole. The architecture is already complete, and the artist is being offered a canvass and a frame.

Design considerations

- create a work that, as a piece, 'stands on its own', yet is an integral part of the building.
- the gates must have visual appeal when closed and when open and when viewed from within and from outside the building.
- embrace the dominance of the glass bricks within the existing architecture

Entrance Gates/Screens, Borders Region Council, Newton St Boswells, Scotland, 1990, each 3 m x 1 m wide.

Designed as an extension to the architecture

Concept

- it will 'conform' to a grid pattern or repeat motif of line and surface which will echo the glass bricks of the existing building.
- the material will be 'modern' and use colour in sympathy with the architecture.
- the design will refer to the agricultural or industrial activity of the region.

Design development and making

The design is geometric through the creation of a stainless steel warp and weft onto which are placed simple repeat motifs giving it a 3D movement. The junctions become a punctuation of colour linking with the architecture. It is made using 'off the shelf' material, cut or guillotined. The connections are welded and the detailing machined. The design and quality is controlled from decisions taken at the drawing board. Visual intent during the making process is absolute. It is David Pye's 'workmanship of certainty'. The main frame of stainless steel, machining and colouring were made in specialist workshops under my supervision. The work was assembled in my studio.

❖

The second distinct area of work is the pursuance of an idea, independent of its environs and often experimental. Here design and process develop organically in the exploration of form and technique suitable to the concept. This can embrace exploration of other materials or the combination of different metals, for example, using precious and non-precious metals within the one object.

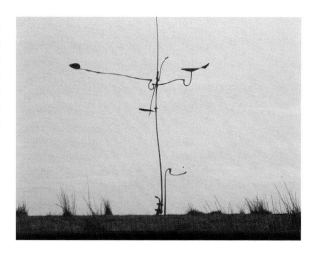

'Bird Table', 1988, explores the linear and flowing qualities of steel when hot forged. The horizontal rotates in response to the natural elements. Height: 4m

Right 'Vase III', 2001. The fluidity of silver held in suspension by forged steel. Ht: 37cm

Far right Coat stand (1999). The simple vertical twist of a strip of steel accentuated by horizontals and their joining points. The ends of the pegs are polished to give a punctuation. The steel will quiver when used. Height: 2.1m

Below right 'Pill Boxes', set of three, 1981. Design inspired by the way a tube can be deformed when bent. Small, intimate, handleable and playful. Using various hinging assemblies. Height of tallest: 6cm. Silver and gold

Working methodology

This will depend on concept and the materials and techniques chosen. Designing for precious metals, where object size is relatively small, allows for an intimacy in the design and making process. Factors of surface finish, balance, weight, choice of materials, hinge articulation, ergonomics, all integrate to give with its shape an object of presence. However, designing within this field demands exacting tolerances. The metal sheet is coaxed into its final form through lengthy

forming processes with little allowance for spontaneity during making. Form and design development can primarily only be achieved during the design stage through the use of drawings, models and templates. This methodology is akin to product design, even for the making of one-offs and can stifle interaction with the work as it develops. It is David Pye's analysis of the 'workmanship of certainty'.

In comparison to this the working of ferrous metal whilst hot has an intimacy which allows a close physical, mental and sometimes spiritual rapport with the material creating a spontaneity which can intuitively develop and enhance the intention. The initial rigidity of the iron bar changes its nature during heating. This plasticity allows the forging process to be expressive and dynamic.

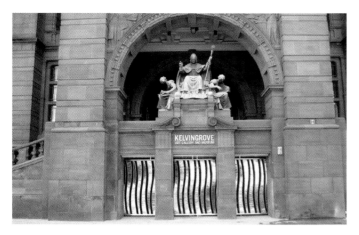

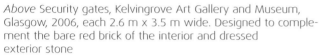

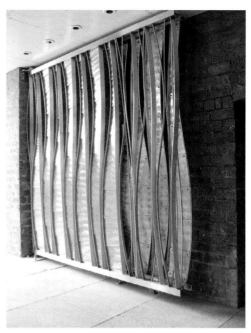

Above Security gates, Kelvingrove Art Gallery and Museum, Glasgow, 2006, each 2.6 m x 3.5 m wide. Designed to complement the bare red brick of the interior and dressed exterior stone

Right Kelvingrove Art Gallery and Museum. View showing how ⅓rd of the gate folds back on itself in the open position to fit the space

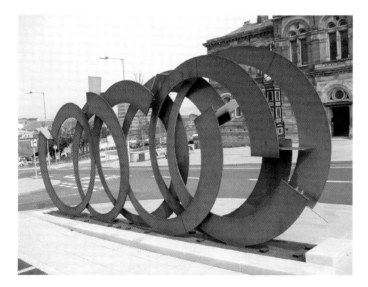

Above Old Town Hall Square, Gateshead, 'Acceleration', pair of screens each 2.5 m high x 7.5 m long, 2005

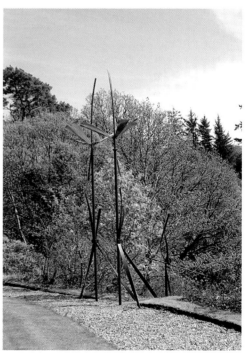

Right Ardtornish Estate, Morven, Scotland. Marker posts (2003) to steps at the top of a cliff. A hand rail is also part of the project. Concept: a pair of posts to designate the position from a distance. A form of 'beacon' at the head of the loch makes reference to a navigational aid. The formalised leaf shapes in polished stainless steel respond to the sun and create a link between man and nature. Height: 5m

ANNA S. KING – Artist

What IS drawing? It is a craft skill that can be taught and learned like any other. The development of one's own visual language can embrace a variety of elements, all relevant and enriching to the process. It is an exercise in hand/eye coordination; a response to any given stimulus, be it visual, aural, tactile, emotional; a preparation for further expression – working drawings, scale drawings, cartoons. It is the creation of a visual dialogue, a visual language.

The idea of drawing is about creativity. If you can draw it, you can make it. Drawing exists as the essential preliminary statement of planning, strategy, technical ability and expression. We develop our own language with the medium. We draw in a way that reflects our innate knowledge of our materials, no matter what our craft skill. We learn the craft of drawing at an early stage in our training and if it is well learnt, then it is never forgotten. We learn the art of the craft and the craft of the art and it all starts with drawing. We learn the basics of anatomy, perspective, landscape and all the other aspects of the art and craft of drawing. We learn to be expressive and abstract as we progress through the training.

And we develop our own, unique, visual language fed by our knowledge of the creative process, visual perception and emotive reactions. In many ways it helps us to live outside of ourselves, this pursuit of an art form, and to live outside of our identity.

Drawing is seeing.
Drawing is looking.
Drawing is a direct response to a visual stimulus.
Drawing is the skeleton, the bare bones of all creative endeavour.

The procedure can take a multiplicity of forms. What is drawing? At its most basic level it can be described as mark-making, with a pencil on a sheet of paper. Look at the cave wall depictions of prehistory: vast herds of animals and hunters, the hunt being essential to their existence.

Think of the 'cup-and-ring' incisions on recumbent and standing stones all over Scotland (a symbol common to other primitive cultures all over the world) perfect in their geometry, deeply mysterious.

Leonardo da Vinci's tiny anatomical explorations drafted in minute detail in his notebooks and Paul Klee 'taking a line for a walk' all have their place in the enormous panoply of the history of drawing. This mode of expression can depict the whole gamut of emotions from great power to fine delicacy.

'Garden' – drawing

Look at the object. See it. Put it down, this, the individual statement. It is like handwriting: we can all do it and we all have our own signature. And so it is with drawing: we all have our own mode of expression, personal and distinctive.

There is an internal and external existence: some things are hidden, screened from view. Do not reveal all of the mysteries: this was once thought to be a woman's perogative. A drawing can mean so many things, as in a one-viewpoint performance or 'fixed stage'; but you may look for the more intense dialogue of a 3D promenade performance. Again, there are many narrative threads.

Drawing can take hours of preparation and forethought before that first mark is made. Observation – both looking *and* seeing – is involved, seeing through any surface attractions and anomalies to what is inherent in the form, the inside story. Looking at the subject: its line, form, how it sits in its surroundings, the space it occupies and the space around it, all are relevant.

Something of great familiarity, seen every day, almost taken for granted in its banality, can suddenly, with a trick of light, become an object of intense interest that demands further investigation. And what better way to investigate than with drawing? Questions are asked, depths are probed and new mysteries are revealed, inviting curiosity.

It can be daunting to sit at a new sheet of paper, exciting, too. The marks are like words, in that once they are uttered,

Right, top to bottom
'Rocks' – drawing
'Hunt' – cave painting at Bimbetka, Madya Pradesh, India
'Hearts are Trumps' – drawing

'Achnabreck' – drawing. *Below*, Leaves & Moss' – drawing *Above* Sketchbook page (drawings)

cannot be unsaid. It is a challenge to commit oneself, certainly no easier with age and experience. It is like the first stage of a journey: there is nowhere on this earth you cannot go, you just have to go through the first door.

Drawing is labour-intensive, but it is a means of arriving at a solution that can be achieved in no other way. And it is so personal: take any group of students given the same subject to draw and they will present as many differing versions of it; the delight of no two people seeing in the same way. No mechanical devices are employed in the craft of drawing: pencil and paper, simply those. The eye's observation, the view transmitted to the brain along the complexities of the optic nerve, processed there along ever-increasing tangles of neurones and synapses, transmitted back down to the hand through the pencil and on to the paper. It all seems so simple, but as yet there is no machine that can simulate the process, especially the uniquely personal way of seeing. Always carry a small note/sketch book and pencil.

Sketchbook pages (drawings)

Below 'Hamseen' – tapestry

All my life I have carried these tools: dozens of note/sketch books line the shelves of my studio. Increasingly I find the notes I take are written: it is so much simpler to write about one's observations so that a deeper, more emotive response can be addressed. Later interpretations can take many forms, into the variety of fibre art techniques I employ.

Sometimes they stay as words, but given their own status in a small book. I have been using drawing as my main means of expression for half a century and it never ceases to amaze and delight. Everything I do starts with a drawing: it has to, as many of the technical problems that arise in the construction of my work can only be solved in this way. 'The back of an envelope' has often served the purpose well, with scribbles that lead on to full-sizes cartoons for the larger

tapestries. For me the drawing is the springboard to the ultimate goal, essential time well spent and I never grudge the time spent on it. Also the very act of drawing something, however small and insignificant, every day, facilitates the process and keeps the hand/eye co-ordination supple; we learn from our materials. I enjoy the discipline of working with a small range of materials – pencil and paper – I can push to the limits the challenge this choice imposes.

What you see is what you want to see. Sometimes you might see something you would rather not admit…but it is relevant to the overall feel of the subject, and necessary to the final solution. Nothing is arbitrary; any decorative additions are metaphors for symbolic and aesthetic reasons, fundamental to my collected experiences. This current way of working – from my written notes – flexes the imagination, that fundamental mystery of human nature and the basis of all creative processes. What language do we dream in? I dream in fibre. We are fibre, our bodies are essentially fibre and tissue, we clothe ourselves in fibre. 'Fibre' can be read as a line, a thread, the drawn statement, that runs through everything we do. The fabric of the universe can be analogous with fibre. Fibre is a seductive and sensual material to work and play with. My conscious endeavour is to allow these qualities to speak through my hands and let their spirit deploy my ideas in the form of highly textured tapestries and other constructed textile pieces. Light plays an important part in these exercises: I rely on the play of light across a surface to give the weaving depth and contour. This play of light and shade adds another dimension to a conventionally two-dimensional surface.

Top 'Sparky' – coiled basket
Left Sketchbook page (drawings)

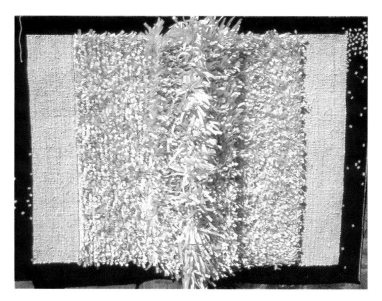

'Grandmother's Secrets, Grandmother's Economies' – tapestry

And there is a serious investment that craft usually commands: the memory of making, perpetuating the craft tradition. In the domestic craft skills of spinning, weaving, dyeing, knitting, basket-making, mostly, in the past, done by women – the mothers and the grandmothers – working intuitively with fibre materials to find a response: this everyday transformation from the personal to a universal perception. There is an intrigue in making a coiled form: of enclosing, protecting and concentrating energies into a small space, concealing some things, regvealing others. I draw on the memory of ancient techniques. I see my baskets as containers for ideas – and secrets.

Craft is becoming a lost world based on history. Let us not lose the reference to the past of the indigenous traditions, domestic and everyday. Our own identity needs vision to express this culture, in many narrative elements.

Drawing is a way of dealing with memory. BUT – don't leave your shadows in a dangerous place.

MATERIALS

Gathered on walks
Tokens of woods and fields
Pine needles, grass, twigs
Of bog-myrtle and birch

Shells, seaweed
Sea birds' feathers
Driftwood, sea-ground glass –
Windswept beaches

Moss and flowers
Lichens from old Scots trees
Mysterious darknesses
Of deep ancient forests

Thread and paper
Unwritten secrets, memories
Unfolding, unearthed
From the past

Endlessly coiling
Twisting and writhing
Lost in the hypnotic
Rhythm of the work

That – and the season's changing

Bending and breaking
Achingly arduous
Pain and bright needles
Of wax-scented thread

Linen, silk, cotton, gold
Binding, confining
Tying, fastening
The coils of the secrets

Ideas and memories
Painful and joyous
A lifetime's gathering
Each one evoked
From childhood's fantasy

Each one a pleasure
Straight from the heart.

DAVID GRANT – Potter – Highland Stoneware

David Grant was born in the North West Highlands of Scotland, and studied Ceramics in Dundee and London until 1974, when Highland Stoneware (Scotland) Ltd was formed with Royal College of Art tutors, Grahame Clarke and the Marquess of Queensberry, as fellow directors.

While I see myself as a potter, much of the work illustrated is by others involved in Highland Stoneware.

We still make the simple range of tableware that was originally produced in the high-fired clay body in a reducing atmosphere, which is the very essence and basis of the language and vocabulary we use.

Highland Stoneware has traded profitably in every year of its existence to date, employing around 26 people each year in custom-built potteries in Lochinver and Ullapool. The making and decorating techniques and the essentially organic growth of what we are inspired to make (and able to sell!) hopefully will contribute a unique chapter to the issues raised by addressing the concept of a visual language, showing how our pieces have evolved through creative observation of the possibilities within the making and decorating processes.

Our work has been developed by the enthusiasm of those working for the Company in an essentially 'hands on' process. Inspired visually by our environment, it has evolved through our materials and techniques. Products are not conceived in marketing meetings, or passed from designers to a production facility as *fait accompli* to be multiplied. Ideas evolve into successful products, with input from within the potteries as well as feedback from customers and users; all helps the positive evolution of works fitted to the world we live in.

Highland Stoneware is an organised structure within which there is great freedom to innovate and experiment. This is mainly, but not exclusively, in freehand painted decoration. We use three making techniques, the main one being the semi-industrial jigger and jolley, which uses moulds and templates. It is efficient and produces in volume items that are appropriate to the technique, and to which painstaking individual painting may later be applied. Hand throwing is, of course, the making method most entirely reliant on the skill and technique of the potter. It is heartening to have a close development process with potters whose individual work is very different, but who are receptive to input from across the Company.

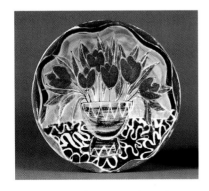 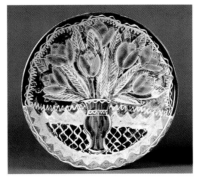

Left hand and centre 2 plates by Tricia Thom, 1988. *Right hand* Heron plate by Lesley Thorpe, 1999

The third making process is extrusion. Probably the most unique piece we have made, 'The Salmon' evolved from this making method. It came about after seeing American potter, John Glick demonstrate smaller scale extrusion at the Highland Craftpoint in Beauly. Apart from the subsequent product development, listening to Glick was crucially important to me in the early 1980s, when we were in the throes of upgrading buildings. His enthusiasm for going to work and 'creating', refreshed my sense of purpose after the necessary chaos and interruptions caused by the making of our superb working environment here in Lochinver and Ullapool.

Development of 'fish dishes'. *From top* Painted by: Tricia Thom 1986, Linda MacLeod 1987, Dorell Pirie 1992, and Dorell Pirie 1996

Before the Glick event, we had been trying, unsuccessfully, to make flat, rolled, fish-shaped pieces for Smoked Salmon. When we realised that extruded particles minimised stress in the clay body, we tried making them in an upright extruder with a single slug of clay and a very long handle upon which two or three people would hang, in order to squeeze the clay through. Instead of coming out straight, the extrusion would twist and turn naturally if not held, so in addition to making flat platters, we realised that it was a natural to make actual fish with the twisty tail as a feature.

All of this burst upon us late one July, and in August I set off for a major Trade Show in New York, via London, clad as ever in the kilt and with a ceramic Salmon in a straw basket. They were a huge success, selling to the big London shops and also stopping the American buyers in their tracks at the Trade Show. A small company needs something distinctive in that competitive melee where the world is on show, and that piece was the best we've done from that point of view.

By that crazy method we made hundreds of dishes in the first year. Later we designed and made our horizontal hydraulic extruder locally, by the sophisticated design and planning process of a discussion by three practical people with reference to a torn matchbox. Using this method, we have made pieces up to 3 feet long, firing them up to 1300°C in three hours.

The evolution in what we make from undecorated tableware in the mid-1970s to the multiplicity of decoration themes we make today, has a number of motivating forces. Initially, we had to increase the value of pots from limited kiln space. Also, many of the themes are inspired by, and grow from, our environment. Successful decoration themes such as Seascape, Landscape, Fish, Rock Pools, Poppy, Puffin, Iris, Wild Berry, Sheep, Pebbles, Thistle, and a large number of floral decorations based

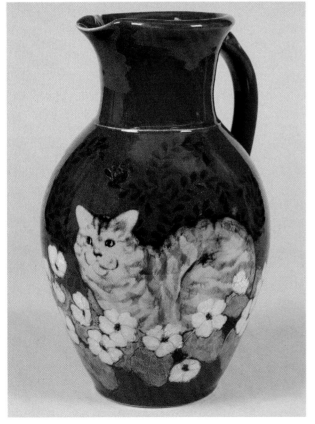

Above Range of 'Sheep' design by David Grant, in production since 1983

Left 'Cat in Flowers', Jug made by Fergus Stewart, decorated by Dorell Pirie, 1998

on local flowers may illustrate the point. A multiplicity of talents have been applied, but despite diverse starting points, comments are frequently made that there is a homogeneity to it all, a 'Highland Stoneware' look, but also that our work is very much 'of the area', in a sense the beginning of a tradition (and they all begin at some time).

The development of new colours has either inspired the concept of these designs or enriched and modified them. There is a good camaraderie in the Company and ideas and effects are shared readily when people cluster round nice pieces as the kiln is opened.

'Seascape' and 'Landscape' account for nearly one third of our annual production and within these headings the variety is infinite. Landscape is virtually reinvented as decorators develop their individual approach, as any artist would if

Above 'Cockerels & Hens', Jugs thrown by Fergus Stewart, painted by Linda MacLeod, 1996. New colours re-vitalised this theme

Right Lamp base thrown by Fergus Stewart, 'White Narcissus' painted by Lesley Thorpe, 1998

the medium was painting on canvas. Going for a walk can bring a new idea to add to the vocabulary, and certainly being on our beaches gives that overall feeling of space and perspective, so vital to keeping work fresh.

I have been more centrally involved in some designs, the 'Seascape' being one of the most significant, as every year the theme is around a sixth of our output. In the early days of new colour experimentation at the start of the 1980s, among many others, we made a very dry white and a particularly strong turquoise green, which we had little use for. Early one January, the young family was round at Achmelvich on a crisp, bright, and very windy day. My son Stuart commented on the 'brutesome sea', and huddling in there, I realised that it was very turquoise green and crisp cold white breakers over dark hard rocks, below a sharp blue sky – exactly the colours of the new glazes.

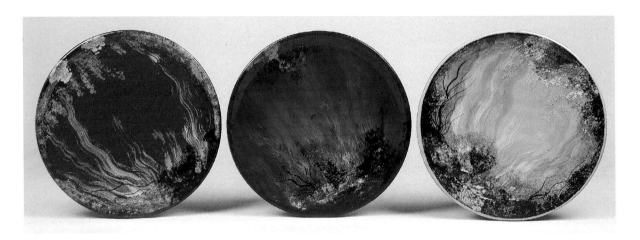

Three 'Rock Pool' pieces by David Grant, on Red, Blue and Celadon glazes. The Celadon platter has been a significant item in our range

Wandering over the shores led to another decoration theme, which has now sold in volume after perhaps the longest gestation period, 'Rock Pools'. The 'Rock Pool' idea came from the lovely qualities available in our high fired reduced stoneware, where layers of colour, washes and overlays give a depth that we can use to convey fluid water with images distorted. It took a long while for this theme to find favour – whether this is due to the appearance of the pieces not being right or fully developed, or them not clicking with the person looking and deciding whether or not to buy, but eventually that theme began to sell well in all our markets, especially to a younger customer. The question of when what seems a perfectly good idea is right for a market is one that exercises us all, and similarly pieces that once were in great demand suddenly are no longer, the trick being for this not to come as an unpleasant surprise.

Another issue raised by producing large quantities is that of repetitive work, and the positive qualities that that brings. Thankfully everyone at Highland Stoneware usually has plenty to do, and when we were commissioned to create a large tableware order based on a waterfall theme for the new Harrods' venture at Shin Falls, I decided that I should paint all of the 150 place settings myself. I was able to lay out big boards to make an angled workstation across the studio to paint in bigger batches. This has led to new folding workstations being designed, and made by our local engineer Graham Anderson.

Having to make every stroke and movement count, I think helps the final quality of the piece. Being under a bit of pressure to get through a workload is fairly normal and must not lead to hashing or rushing, but thinking through and sequencing efficient output can be a pleasure. Loading a big brush to do all of the white on a piece using different strokes as the colour dries, or putting a small sponge mark of a colour on many pieces at a time makes for a different type of work, all many miles from designing on a drawing board.

The last two examples of pieces evolving from the processes also incorporate making as well as surface decoration. We enjoy visits from potters and artists, and Kaffe Fassett's visits are particularly inspiring and energised, not least as he has to get up and get going on work at first light. In the northern summer, it's seldom dark! One day we were out for a walk, and took pebbles back for reference to work from, with of course very different approaches, and no prizes issued for results. My work led me from painting and using all the dry colours in our palate, to making actual pebble shaped pieces. The lads jolleyed

Right Tile panel by Pippa
Peacock, 1998

Below 'Rock Pool' trial pieces by
David Grant, 1986–1990

plates and bowls on the moulds, and we immediatly cut the fresh clay asymmetrically, into varying soft pebbly forms. These were glazed in the very dry white used for seascape waves. We could not see any use for this glaze for anything tableware related for over 20 years, but experimenting now showed that all the other decorating pigments reacted completely differently, especially in thin watercolour type washes on this hard non-absorbent surface, as opposed to blending in light refractive layers in our main glazes. Any colour containing copper oxide bled rather nicely and any shiny pigment quickly made the base glaze surface practical in use.

This is one of the few examples of some customers commenting that these do not look like Highland Stoneware, and indeed for a few stockists, mixing them in with their displays has not always worked with their customers. The early Rock Pool was just like that, and while 'Pebbles' may not grow to that percentage of turnover, it is encouraging that some people are really enthused, and in addition to my own family, they include designers and makers in textiles and jewellery and ceramics, so my hope is that their perception is ahead of the market.

The other feedback from the dry white is realising the ephemeral cloudlike qualities it has, and by applying the white as an underwash to the 'Seascape' and 'Landscape' skies, these themes are given a quite different look.

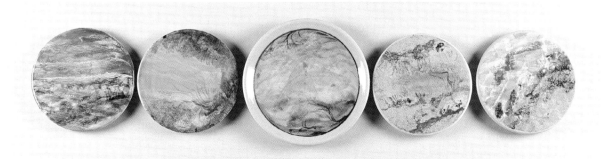

ALISON McCONACHIE – Glassblower

My chosen material is glass. It is a glorious and seductive substance that has an inherent beauty that is difficult to deny or defy and can inhibit critical analysis.

My chosen method of making is glass blowing. At present, I tend to work alone. It is an intense and physical event that has its own profound effect on the outcome. The intention and the process are inextricably bound together. Decisions about form and line are being made constantly throughout the blowing. Balance, timing, and a knowledge and instinctive understanding of the material built up by practice are all important factors as is chance, the unforeseeable and unpredictable element that can spoil or damage but can also lead to new discoveries.

A series grows and develops slowly as I learn from each new piece of work. Drawing can help to lead me toward the shapes I want to aim for. It can show me the line that I want to draw in the air with the glass. However, the drawing that I do somewhat sporadically now is more likely to be an abstract journey with line, colour and texture than a description of what I will create in glass.

The vessel draws together beautifully all the elements discussed in this book. I am drawn to the generosity and warmth of the vessel form. It is a strong, feminine shape that allows me very personal expression and lets me work at a scale that gives a feeling of real presence to the pieces.

The impetus for this series of vessels was a trip to Venice. I came home with colours and sensations that were my experience of the city – its smell, the water, the reflected light on the walls from the canals, the antiquity, the richness of its beauty. 'Ausonian I' (fig 1 and detail, *opposite*) was the first to emerge from the exploration of that absorbed and assimilated information.

There are many factors that affect the form in the blowing process.

My initial choice of colour is made in order to create the desired atmosphere within the piece. However, some colours are harder than others, some are very soft. A soft colour may expand very rapidly when placed beside a hard colour forcing too thin an area in one part of the bubble leaving a thick section where the hard colour has not blown out sufficiently. This can cause an extreme imbalance in the form and make a satisfactory shape difficult to achieve. Therefore, I have to spend considerable time working with a range of colours until I find a group that will work for me technically but will also give me the intensity I am looking for.

I want the colour to lie unprotected on the inner skin of the form, as this is where I will break into it with the sandblaster and glue treatment when cold. I also want to lighten the piece and balance the strong colour with a clear rim section. To achieve this, I construct a bubble made of an open tube of clear glass with one or often two colours wrapped in rings around the mouth of the tube. The final ball of colour seals the tube to become a bubble. This is then coated in three layers of glass to collect the required weight and thickness for the scale of the vessel, and is blown to shape. Regularly throughout the making, the glass is reheated to keep it malleable and is shaped with wood and metal tools and a wet paper shaping pad.

In order to open the form, a punty iron is attached to the base of the bubble and the neck is broken away from the original iron. As the re-heated mouth of the form softens and opens, its shape is controlled

by wooden tools. When it is almost completed, the hot side of the vessel is rolled on metal leaf which fires onto its surface and the increased heat attraction to that spot in final reheating will give a last and distinctive movement to the form. Throughout the making process, the form is constantly being assessed and adjusted. The final moments of opening are particularly important as the relationship of the lip of the piece to the body form creates much of the character of the vessel.

The glass requires to be cooled in an annealing oven very slowly overnight to release stress. As each form emerges from the cooling process, it undergoes a critical assessment of its shape, line, attitude, colour, section, weight, scale and material quality. Most, if not all of these have to be successful in order to make it worthwhile proceeding with the next stages.

The most successful forms that I have made give me the feeling that they have either just landed or are about to rise into the air. I want the most delicate connection possible with the surface on which they sit. Each has a direction that the attitude of the form primarily gives and that is built upon by the movement of the colour in the piece. There is usually an unmistakable alignment, a front and a back to the vessel often enhanced by the application of gold or silver leaf. It is critical that the flat grinding of a base on which the piece will stand relates to all these factors.

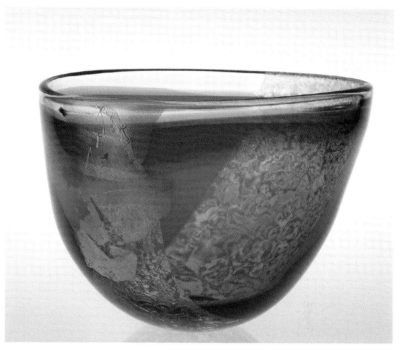

Photograph by Shannon Tofts

Photograph by Shannon Tofts

As the outer line of the piece is drawn in the air during blowing, the inner line is created by the edge of the texture. I want a swathe that will sweep through the centre, cutting through the circular rings of colour to accentuate the direction of the form. The process of masking the area to be protected allows much time for this line to be worked and re-worked until the movement through the whole piece flows. Recently, this line has escaped from the inside onto the outer surface to complete its movement around the vessel, breaking into areas of the perfect, smooth, reflective outer skin with texture. (fig 2, *right*)

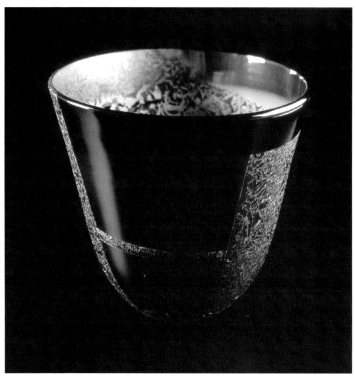

Photograph by Shannon Tofts

Two or three layers of colour are laid on the inner skin in the hot process, both transparent and opaque. The purpose of the hide glue process is to break into the colour layer in a semi-controlled fashion (this is not entirely predictable though the aggressiveness of this action can be varied according to the water/ glue ratio). Not only does it create beautiful effects with the colour as it bites back toward the clear glass, but also it brings light into the centre of the piece. The smooth glass surface needs a key for the hot glue to hold onto and sandblasting is a perfect ground. Once frosted by the sandblasting, glue is poured hot onto the glass and then allowed to harden off. When the piece is re-introduced to a warm atmosphere, the glue cracks and peels itself away from the surface removing a layer of glass in fern-like curls. (fig 3, *right*)

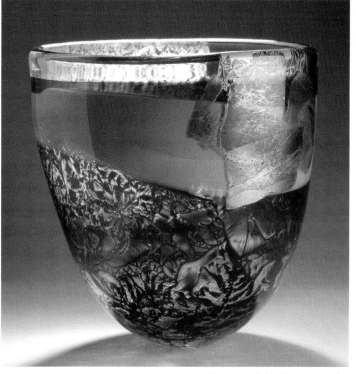

Photograph by Shannon Tofts

103

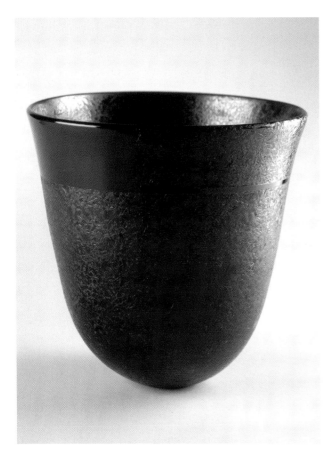 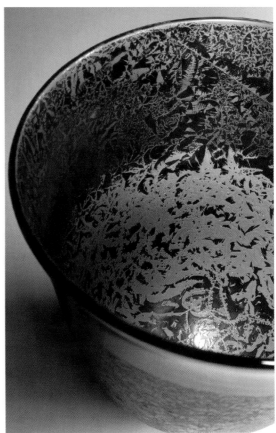

Photographs by Shannon Tofts

Light behaves in a wonderfully special way with glass. The effect of a light beam passing through a rich seam of dense, saturated colour is mesmeric. Some glasses are almost opaque in reflected light but become a different, glorious, transparent colour in transmitted light. Light passing through a form will throw beautiful colour and shadows that can be manipulated by surface treatments that alter the glass wall such as sandblasting, cutting, engraving and chipping. My most recent work explores dramatic contrasts of colour and surface with very little light passing through the wall of the pieces. Reflected light on texture and lustre is of the utmost importance for these vessels. (fig 4 and detail)

Good lighting brings glass to life.

David Cohen – Beyond fundamentals

My working methodology was influenced by an apprenticeship as a joiner (carpenter) and then as a metalsmith. This early experience compounded not only a great respect for materials but an appreciation of the time necessary to achieve competence and, from this, a sense of pride in the end product. The time involved in mastering the practical can never be over-emphasised or taken for granted.

Through an art education (1958 – 1962) I was introduced to the possibility of converting personal ideas into individual visual statements. Ultimately clay became my primary working medium. Unlike wood or metal, clay does not have a recognisable form or immediate structural use, and presents a multitude of different challenges. The important factor which did not change was a respect for the time needed, as with wood or metal, to become one with the clay.

The evolution from the raw clay to a finished product involves four elements – the earth where clay is found, water to make it workable, air for drying, and fire for permanency. In the respect I acquired for process and materials, clay became an ultimate challenge. There is also the mystery of the 'waiting game', the firing process of converting the clay into a durable product. Firing also changes the qualities of colour and density.

Through a fascination with mechanical devices and their capabilities I started to make machines that related to clay: pugmill, kilns, potter's wheel, blunger, and mould making equipment.

This pugmill (*below left*), built in 1965, and still going strong, is basically a machine designed for the purpose of mixing and consolidating the clay and extracting the air to improve plasticity. This eliminates the laborious job of hand wedging. It was not, as in the case of the potter's wheel, initially designed for functional or creative work. It was not until 1973 that I designed an ambitious piece of sculpture of ceramic and metal (*below right*) using the extrusions directly from the pug mill.

Working beyond fundamentals is assessing the possibilities which are beyond intended function and convention. It is at this point the pugmill began to serve the idea. In industry the pugmill is used to extrude shapes both solid (building bricks) and hollow (clay waste pipes).

De-airing pugmill

Ceramic and metal sculpture, 1978

Metal extrusion template Clay being extruded Extruded wall installation, 1998

This recognition of the hollow extrusion began, for me, an entirely new direction in the use of the pugmill as a creative instrument in the same way as I regard the potter's wheel. The de-airing facility of the pugmill, which is part of its basic function, gave me the possibility of twisting, bending, and distorting hollow shapes as they are extruded without cracking.

In the year 2000 I was invited to have an exhibition at the East Kilbride Art Centre, Scotland. In undertaking this commitment, an assessment of the exhibition space with the consideration of lighting and other architectural limitations was given first priority. The area which impressed me most was looking outwards from the Art Centre's restaurant. A large rectangular pool was situated in front of a terraced garden and the outdoor area presented an opportunity to work in an entirely new environment. All the associations with nature would have to be considered in the concept of the work and its placement. Light and shadows would constantly change with water adding its own dimension of reflective qualities. The architectural layout and the established plants could not be moved or altered. How

the work would integrate or contrast with these features and physically be secured also had to be solved. After considerable deliberation I decided to associate the work with natural growth rather than an architectural format of geometric shapes. Up to this point my experience with large-scale free standing work was practically nil. My only reference point was the large-scale installations exhibited at the Glasgow School

'Dynamic Growth', East Kilbride Art Centre, 2000

'Dynamic Growth', East Kilbride Art Centre, 2000

of Art, and the Aberdeen Art Gallery. In both cases the idea of multiplying a small unit to create a large scale work was employed. The hollow extrusion from the pugmill offered the solution of producing units of various sizes and designs capable of being multiplied and associated with natural growth.

The culmination of past experiences in relation to problem solving has taken me beyond basic fundamentals. This is seldom referred to in books dealing with basic techniques, and is ignored as being too basic in any philosophical or intellectual reference to ideas and individual pursuits. The more knowledge acquired relating to the creative process of making, the greater the ability for solving problems. The reference point of past experiences has always served my momentum to move forward in the pursuit of new challenges. East Kilbride contributed an abundance of new information which has become a valuable addition to my visual vocabulary.

<center>❖</center>

Producing work for a market or exhibitions are the two avenues most usually followed by craft people. In the last couple of years my energies have been focused on a feature, concrete blocks, that was imposed on nature along the eastern coastal regions of Scotland. These concrete blocks are visually and historically fascinating because of their shape, quantity, and reason for being positioned this way. They were not conceived as conceptual art but had practical roots which were fortunately never used for their original purpose: to prevent German tanks invading Scotland from Norway. These blocks measuring 3ft square x 4ft high were made over 60 years ago. In the illustrations the different environments are evident. On close inspection the effects of both exposure to, and protection from, nature can be fully appreciated.

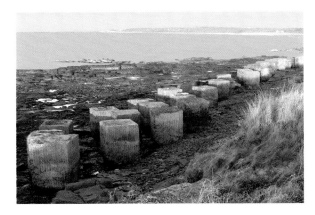

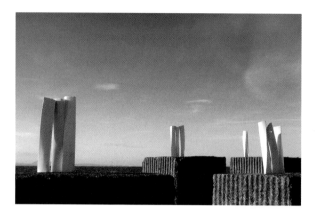

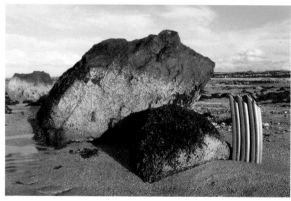 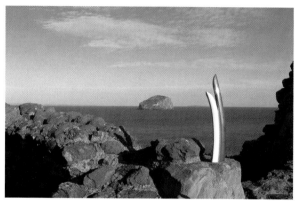

Over the last 20 years my fascination with these blocks has not diminished. Since my exhibition at East Kilbride, I have contemplated the idea of an interaction between the blocks and the extruded clay. It is only now, through photography, that the possibility of the visual communication of my intentions can be realised. It is this intimate relationship between the natural world and the placement of these man made extrusions which has become an ongoing activity, without the restriction of time limitations or exhibition commitments. My critical assessment is now evaluated through the evidence of the photograph. The values of light and compositional organisation of the natural settings in relation to the extrusions have become an end in itself.

The concrete blocks served as a catalyst by extending the ceramic extrusions into other natural settings. Working in this way has been a welcome step out of the environment of the studio. I no longer consider the extrusion as a primary element. It is a contrasting component within a natural habitat. The relationships of all the basic visual elements of line, shape, tone, colour, texture, form, scale, space and light, which are all considered in the selective and compositional process, are communicated to the viewer through the photographic presentation.

Bibliography

Bailin, Sharon (1994) *Achieving Extraordinary Ends: Essays in Creativity*, Ablex Publishers.

Berger, John (1972) *The Look of Things: Selected Essays*, London: Penguin.

Blackburn, Simon (2001) *Think*, London: OUP, p. 4.

Cole, D.G., Sugioka, H.L. and L.C. Yamagata-Lynch (1999) 'Supportive Classroom Environments for Creativity in Higher Education', *Journal of Creative Behaviour*, 33, p. 277.

De Sausmarez, Maurice (1964) *Basic Design*, London: The Herbert Press, an imprint of A&C Black.

Geddes, Sir Patrick, *Biology and its Social Bearings*.

Ghiselin, Brewster (1985) *Creative Process: A Symposium*, University of Calaifornia Press.

Guichard-Meili (n.d.) *Matisse Paper Cut-outs*, London: Thames & Hudson.

Jones, Anthony (1990) *Charles Rennie Mackintosh*, Studio Editions.

Landry, C. and Franco Bianchini (1995) *The Creative City*, London: Demos.

Moffat, Alistair (1990) *Remembering Charles Rennie Mackintosh*, Colin Baxter Photography Ltd.

Moignard, Elisabeth (2003) *Jack Cunningham – On the Line*, p. 14.

Noller, Ruth B., Isaksen, Scott G., Dorval, K. Brian and Donald J. Treffinger (2000) *Creative Approaches to Problem Solving: A Framework for Change*, Kendall Hunt Publishers.

Pye, David (1978, 1982) *The Nature & Aesthetics of Design*, London: The Herbert Press, an imprint of A&C Black.

Pye, David (1968, 1971) *The Nature and Art of Workmanship*, London: The Herbert Press, an imprint of A&C Black.

Schoenfeldt, L.F. and J.K. Jansen (1997) 'Methodological Requirements for Studying Creativity in Organisations', *Journal of Creative Behaviour*, 31, p. 73.

Simpson, Ian (1992) *Drawing, Seeing and Observation* 3rd edition, London: A&C Black.

Index

Also available from A&C Black:

Basic Design
Maurice de Sausmarez
0-7136-8366-X

**The Nature and
Art of Workmanship**
David Pye
1-871569-76-1

**The Nature and
Aesthetics of Design**
David Pye
0-7136-5286-1

Drawing Matters
Jane Stobart
0-7136-7084-3

**Drawing, Seeing
and Observation**
Ian Simpson
0-7136-6878-4

Inspirational Objects
Alison Milner
0-7136-6819-9